UTSUWA KATACHI
JAPANESE CERAMICS AND FORMS

うつわ かたち

UTSUWA KATACHI — JAPANESE CERAMICS AND FORMS

DATE OF PUBLICATION: FIRST PRINTING JULY 7, 2016
SECOND PRINTING APRIL 23, 2024

—

AUTHOR:
TOMOO SHOKEN

PHOTOGRAPHS:
YUSUKE NISHIBE

BOOK DESIGN:
FUYUKI HASHIZUME

TRANSLATION:
MANAMI TOMINAGA

COOPERATION:
KAZUYOSHI SUGITANI
WATARU HATANO

PUBLISHER:
KEIKO KUBOTA

PUBLISHING HOUSE:
ADP COMPANY | ART DESIGN PUBLISHING
2-14-12 MATSUGAOKA, NAKANO-KU, TOKYO 165-0024 JAPAN
TEL: 81-3-5942-6011 FAX: 81-3-5942-6015
http://www.ad-publish.com

—

PRINTING DIRECTION:
KATSUMI KUMAKURA (YAMADA PHOTO PROCESS, INC.)

PRINTING & BINDING:
YAMADA PHOTO PROCESS, INC.

—

©TOMOO SHOKEN 2016
PRINTED IN JAPAN
ISBN978-4-903348-48-3 C0072

—

ALL RIGHTS RESERVED.
NO PART OF THIS PUBLICATION MAY BE REPRODUCED OR TRANSMITTED
IN ANY FORM OR BY ANY MEANS, ELECTRIC OR MECHANICAL, INCLUDING
PHOTOCOPY, OR ANY OTHER INFORMATION STORAGE AND RETRIEVAL SYSTEM,
WITHOUT PRIOR PERMISSION IN WRITING FROM THE ADP COMPANY.

目次 | CONTENTS

UTSUWA KATACHI | うつわ かたち
JAPANESE CERAMICS AND FORMS

Foreword		はじめに
Bowl	7	碗
Dish	31	皿
Larger-type bowl	47	鉢
Teapot and tea cup	71	茶器
Katakuchi	94	片口
Sake bottle and sake cup	106	徳利
Lidded vessel	114	ふたもの
Jar and vase	120	壷
Ceramist Interview		インタビュー
YUJI MURAKI	131	村木雄児
YAKU MURAKAMI	140	村上 躍
ATSUSHI OGATA	149	尾形アツシ
Index	158	索引

FOREWORD

The Japanese word utsuwa literally means "vessel" or "container", and commonly refers to any kind of cup, plate, dish, or pot. The word seems to have an onomatopoeic quality of softness and roundness when uttered, mimicking the shapes of the objects it signifies. These gently curved forms are so delicate that they sometimes look as if they might float off the ground, and they can fill one with a sense of security and snugness, much like the sensation of being covered up in a soft blanket.

If you align your two little fingers and cup your hands together, you make the basic shape of an utsuwa. You may very well have used your hands in this way before, as a method of scooping up water from a river or basin, for example. The physical shape of this cupped palm seems to give us some insight into the origins of the Japanese concept of utsuwa; a word that is also used to refer figuratively to a sense of humility and gratitude (someone who is magnanimous and open-hearted is said to have a large utsuwa, while people who are petty and vindictive are said to have a small utsuwa). Perhaps humility and kindness are innate qualities in humans. An important aspect of making an utsuwa is the limitation imposed on the process by the fact that it is a thing designed for human use. Made to be held in our hands, utsuwa are, in their original conception, things of beautiful simplicity and unadornment.

Now, when you look into a cup, what do you see? It will inevitably be empty; a vacant space. The initial impression is that there is nothing there to see. Yet gazing at it more closely, one begins to notice the intricacies and peculiarities of its form. And like any other piece of art, it reflects the artist's bodily rhythms, emotional state, and relationship to his environment. There have been ceramists dedicated to the craft of utsuwa in all continents and throughout all ages, and to this day, their handicrafts continue to give us insight into their dexterity and creative joy.

Ceramic artists persistently think about the forms of their works. They think with their hands, so to speak, and turn their inspiration into physical objects by means of those same hands. Yet these objects are in a continual process of change.

Unlike mass produced crockery, for which the process of molding to firing is tightly controlled, the spontaneous ceramic form is momentary and fleeting. The particular clay or raw material used, the thickness and flow of the glaze, the condition of the kiln; an individual piece of pottery is dependent on a distinct balance between all of these factors, and no one piece is identical to another. As a result, every encounter with an utsuwa is said to be unique and a once-in-a-life-time experience.

The utsuwa that we use should fill us with a sense of warmth and aesthetic pleasure. Their forms are made in our very own palms, and mature in our very own hands.

はじめに

うつわ、と口にしたときに感じられる、やわらかなニュアンスは、多くのうつわが有している丸みのあるかたちに由来している。ふんわり舞い降りてきたようなやさしい丸みのあるかたちは、やわらかな布で身体を包まれるような安堵感をあたえるものです。

ふたつの小指をあわせ掌を丸くすると、うつわのかたちがあらわれてきます。たとえば清流で水をすくい口元に運ぶとき、自分の掌が道具になることを経験した方は多いでしょう。この掌のかたちこそ、うつわの原点であり、大切なものをいただく、という心のかたちでもあります。人は自らのなかに、もともと、この慎ましく謙虚な心を持ち得ているのかもしれません。

うつわのかたちを作る大きな要素のひとつに、人が使うための道具であるがゆえの制限があります。人の手に包まれるがゆえ、うつわは、本来、簡素で無駄がなく美しいものです。

さて、うつわを覗き込むと何が見えるでしょうか。実は、そこにあるのは空と同じ、うつろなるもの、空（くう）なるものです。何かを盛られるまで器は空っぽであり、何もありません。けれど眺め続けるとやがて気がつくでしょう。そこに確かなかたちがあることを。身体のリズムや心のありかた、土との向き合いかた、それらは作り手自身の姿を投影したものです。作り手は世界のどの大陸にもどの時代にも存在し、今日に至るまでうつわを作り続けてきました。のびやかな手の動きや作る喜びのようなものを、わたしたちは時を経て、感じることができます。

作り手は常にうつわのかたちを辛抱強く問い続けています。彼らは、自らのわき上がるものを源泉とし、手でものを考え、手を動かし、そして信じるものをかたちにします。しかし、そうして生まれたかたちは常に変化を続けます。成形から焼成の過程までコントロールし、量産を可能にする工業製品とは異なり、いまあらわれたかたちは、次の瞬間には存在していないのです。原料の土、釉薬の厚みや流れかた、ひと窯ごとの調子、あらゆるバランスのうえにうつわは作られ、ひとつとして同じものはありません。それゆえ、うつわとの出合いは一期一会と言われます。

わたしたちの手が求めるうつわは、温もりにあふれ心打たれるものです。うつわのかたちは、人の掌から生まれ、人の手のなかで育っていきます。

碗は掌で包むかたち。
慈しみ、いただくかたちを基本とする。
慎ましく繊細な、感謝をあらわす
美しいかたち。

The shape of a bowl resembles the form of clasping both hands together.
The basic expression of cherishing and receiving.
A beautiful shape that is humble, delicate and an expression of gratitude.

Bowl, White porcelain with iron glaze by Naotsugu Yoshida | φ: 13.6cm H: 9cm

Kohiki rice bowl by Yoshio Kangawa | φ: 11cm H: 6.3cm

Kohiki rice bowl by Fuminari Araga | φ: 13cm H: 6.5cm

Oribe rice bowl by Teppei Terada | φ: 13cm H: 5cm

Rice bowl with black glaze by Shigeyoshi Morioka | φ: 12.5cm　H: 6cm

Mishima rice bowl by Yuji Muraki | φ: 12.5cm H: 6cm

Mishima rice bowl by Yuji Muraki | φ: 12~13cm H: 6~6.5cm

Karatsu teabowl by Yuji Muraki | φ: 14.3cm H: 8.1cm

Korai teabowl with black glaze by Shin Murata | φ: 12.5cm H: 7cm

Rice bowl, White porcelain by Tsunehisa Gunji | φ: 13.5cm H: 7.5cm
Rice bowl with ash glaze by Tsunehisa Gunji | φ: 13.5cm H: 6.8cm

Rice bowl, Celadon by Koreya Anan | ϕ: 10.5cm H: 6cm
Rice bowl, Blue and white porcelain by Takaaki Yoshida | ϕ: 11.5cm H: 6.5cm
Rice bowl, White porcelain with ash glaze by Koreya Anan | ϕ: 10.5cm H: 6cm

Bowl, Brushmark slip by Banri Yoshioka | φ: 15cm H: 7.5cm

Bowl with Karatsu glaze, kintsugi by Teppei Ono | φ: 14.2cm H: 6cm

Bowl, Nanban Yakishime by Makoto Ishida | φ: 14.1cm H: 7cm

Bowl, Brushmark slip by Atsushi Ogata | ϕ: 15.8cm H: 5.5cm
Kohiki bowl by Atsushi Ogata | ϕ: 13.6cm H: 6cm

Bowl with ash glaze by Atsushi Ogata | φ: 14.2cm H: 6cm
Kohiki bowl by Atsushi Ogata | φ: 15.7cm H: 7cm

皿は姿勢のよいかたち。
芯のある美しさが問われる。

Plates have a form with a good posture.
Its inner core beauty is timeless.

Octagon plate, Blue and white porcelain by Shin Murata | φ: 24cm H: 4cm

Oval plate, Blue and white porcelain with lapis lazuli glaze by Shin Murata | φ: 21.5cm H: 2.4cm

Rim plate, White porcelain line engraving by Daisuke Kameta | φ: 24cm H: 3.8cm

Dish, White slipware by Takuya Yokoyama | φ: 15cm H: 2.8cm

Dish, White porcelain with iron glaze by Naotsugu Yoshida | φ: 22.6cm H: 1.8cm

Board plate by Toru Hatta | W: 23.5cm D: 23.5cm H: 1.8cm

Square plate, White porcelain by Akihiro Taniguchi | W: 12.5~23.5cm D: 12.5~23.5cm H: 1~1.8cm

Kohiki dish by Ryo Aoki | φ: 13.5cm H: 3cm

Small dish, White porcelain by Masaomi Yasunaga | φ: 11.5cm H: 3cm

Small dish, Nanban Yakishime by Shigeyoshi Morioka | φ: 11.5cm H: 3.5cm

鉢は盛りつけるうつわ。
どんな料理も受け止める度量の広さ。
のびやかな曲線、広がりがあるかたち。

The bowl is for serving up food.
Versatile to receive any type of cuisine.
Carefree curves and forms with expansion.

Mishima bowl by Toru Hatta | φ: 19.5cm H: 8.5cm

Octagon bowl with black glaze by Tasuku Mitsufuji | φ: 5~18cm H: 6.5~7.5cm

Square foot dish, White slipware by Takuya Yokoyama | W: 10cm D: 10cm H: 4cm

Foot bowl, White porcelain by Daisuke Kameta | φ: 14cm H: 5.8cm / φ: 15cm H: 5cm

Small bowl, Semi porcelain by Yoshio Kangawa | φ: 12cm H: 5cm

Triangle bowl, White porcelain by Naotsugu Yoshida | φ: 14cm H: 6cm
Triangle bowl with iron glaze by Naotsugu Yoshida | φ: 15cm H: 5cm

Glass bowl by Keiichi Mimata | φ: 20cm H: 12cm

Mishima bowl by Yuji Muraki | φ: 25cm H: 8.5cm

Oribe bowl by Shimao Kiso | φ: 28 × 25 cm H: 10.5cm

Bowl, Combing gong-shaped by Teppei Ono | φ: 29.5cm H: 5cm

Large bowl with ash glaze by Shigeyoshi Morioka | φ: 31cm H: 8.4cm

「気持ちのよい茶器を手に入れて人生を愉しもう」

" Let us enjoy life by obtaining a tea ware that rewards you with a pleasurable experience "

Pot, Black Yakishime by Yaku Murakami | φ: 9.5cm H: 9cm

Pot, Red rust make up by Yaku Murakami | φ: 10.5cm H: 10cm

Pot, Wood fired kiln by Teppei Ono | φ: 9cm H: 9.5cm / φ: 8cm H: 8.5cm

Pot, Color make up by Katsunori Yaoita | φ: 7cm H: 11.5cm

Pot, Yakishime by Atsushi Ogata | φ: 9.5cm H: 12.5cm

Pot, Brushmark slip by Atsushi Ogata | φ: 11cm H: 13cm

Pot, White porcelain by Tsunehisa Gunji | φ: 10cm H: 12cm

Teapot, Yakishime by Masaomi Yasunaga | φ: 8cm H: 7cm

Pot, Overglaze enamels by Banri Yoshioka | φ: 10cm H: 11cm

Coffee cup with iron glaze by Naotsugu Yoshida | φ: 8.1cm H: 6.2cm
Coffee cup, White porcelain by Naotsugu Yoshida | φ: 8.2cm H: 6.5cm

Bowl, White porcelain with iron glaze by Naotsugu Yoshida | φ: 7cm H: 6.6cm

Teabowl, White porcelain with ash glaze by Naotsugu Yoshida | φ: 7cm H: 7cm

Kohiki teabowl by Ryo Aoki | φ: 6cm H: 7cm
Mishima teabowl by Ryo Aoki | φ: 7cm H: 6.5cm
Kohiki teabowl by Ryo Aoki | φ: 6cm H: 7.5cm

Teabowl with iron painting by Teppei Ono | ϕ: 6.3cm H: 7cm

Sobachoko, White porcelain line engraving by Daisuke Kameta | φ: 8.5cm H: 6.6cm

Kohiki teabowl by Ryo Aoki | φ: 9cm H: 7.5cm

片口はすがた。
哲学者のような貌をして
堂々とこちらを見つめている。

A Katakuchi has its own character.
It has an expression akin to a philosopher
that gazes at you knowingly.

Katakuchi, Brushmark slip by Ryo Aoki | φ: 15cm H: 7.5cm

Katakuchi with ash glaze by Naoko Taya | ϕ: 6cm H: 4.3cm

Katakuchi, Combing by Teppei Ono | W: 11.5cm D: 14cm H: 8cm

Katakuchi, Hand forming by Soji Tsurumi | φ: 7.5cm H: 10cm
Katakuchi, Silverdecoration by Yaku Murakami | W: 9cm D: 9cm H: 10.5cm
Katakuchi, White porcelain with iron glaze by Naotsugu Yoshida | φ: 8cm H: 7.8cm

気配を残す、
余韻あるかたち。

A shape that has a presence,
that leaves a certain reverberation in the air.

Katakuchi, White slipware by Takuya Yokoyama | φ: 12 × 8.3cm H: 6.5cm

Black Katakuchi by Takuya Yokoyama | φ: 9.5 × 9cm H: 8cm

Katakuchi with ash glaze by Atsushi Ogata | φ: 18cm H: 8.5cm

Pitcher with zaffer glaze by Teppei Ono | φ: 10.5cm H: 17.5cm

誰かの価値ではなく、
自らの身体性において、選ぶ。
それがうつわの価値である。
触れる。使う。愛でる。
身体のありかたに理由があるように
かたちには理由がある。
そこに真実があるかどうか、
問われているのはこの一点である。

To make a choice based on one's own experience, not through someone else's values.
That is where the true value of the utsuwa lies.
Through touch. Through use. Through love.
In the same way as there is a reason for the way of the physical body, there is a reason for a shape.
The only thing that matters is whether there is truth within.

徳利は誘う。
色気のあるかたち。

Allure of the Sake Decanter.
A form with seductiveness.

Kohiki sake bottle by Nobuhiko Oyama | φ: 8.3cm H: 10.3cm

Sake bottle, White porcelain faceted by Shin Murata | φ: 6.5cm H: 9cm

Sake bottle with lapis lazuli glaze by Shin Murata | φ: 8cm H: 12cm

Kohiki sake bottle by Fuminari Araga | φ: 6cm H: 15cm

Sake bottle, Slipware by Makoto Ishida | φ: 5cm H: 12.5cm

Kohiki sake cup by Atsushi Ogata | φ: 5.5cm H: 5.5cm
Kohiki sake cup by Atsushi Ogata | φ: 5.5cm H: 6cm
Sake cup with iron painting by Shin Murata | φ: 5cm H: 5cm

Mishima sake cup by Yuji Muraki | φ: 6.5cm H: 4cm
Kohiki sake cup by Ryo Aoki | φ: 9.3cm H: 4.3cm
Sake cup, Brushmark slip by Shin Murata | φ: 8cm H: 3cm

A lidded vessel. A hidden secret.

ふたもの。密やかな約束。

Lidded vessel, White porcelain faceted by Yuriko Morioka | ϕ: 12cm H: 11.5cm

Lidded vessel, Finger drawing by Teppei Ono | φ: 9.5cm H: 13.5cm

Lidded vessel with overglaze enamel by Banri Yoshioka | φ: 10cm H: 11cm

語らずとして語る、もの言わぬ存在、壺。
見つめ、見つめられるかたち。

A pot is a silent entity, who speaks without words.
A form that gazes and is gazed at.

Jar with iron glaze by Ryo Aoki | ϕ: 16cm H: 20cm

Vase, Combing by Teppei Ono | φ: 6~24cm H: 8~24cm

Vase, White sand make up by Yaku Murakami | W: 41cm D: 20cm H: 23cm

Jar, White porcelain by Yuriko Morioka | φ: 25cm H: 27.5cm

Big jar with natural ash glaze by Atsushi Ogata | φ: 58cm H: 62cm

CERAMISTS INTERVIEW

MURAKI YUJI

村木雄児

When I started out as a ceramist, I would print spiderwort patterns on white kohiki ceramics and paint pictures on blue and white porcelain. Yet through trying out various firing methods, I came to be more interested in the changes of the textures and expressions of the clay itself, and I stopped drawing onto my works. Since then, I have distanced myself from the old established techniques such as kohiki, mishima, and kaiyu ash-glazing, working instead without any orthodox principles or values to guide me. From clay-making to glazing, I handle every process myself, and my love of pottery has remained the same throughout the years.

When I think about Japanese ceramics, or utsuwa, I immediately imagine the Japanese rice bowl or teacup. I am personally very fond of potter's wheels, and a form that fits neatly into the hands has a special quality for me, from the moment I start spinning the clay. The appeal probably lies in the process of choosing the clay, turning the wheel, and shaping the piece in one's own hands, with complete freedom. Sometimes I stop the wheel in mid-spin, because I like a certain line. I can also spontaneously decide on a different shape to the one I originally had in mind. In effect, this method allows me to work completely as I like. With rice bowls, you make several at a time, and therefore get a sense of rhythm and momentum in the process. If there happens to be, for example, a small stone in the clay, that kind of accident can cause the form to change serendipitously, and so the pieces start to vary and branch out. With larger works, this kind of flexibility and play with accidental factors is not so easy. It is because a piece fits into one's hands that it is so malleable, allowing the ceramist to shape his work freely and impulsively. Such is the form of the bowl. In the past too, ceramic artisans made their works according to a set of trusted methods and processes. Their personal moods and the conditions of the clay that they used shaped their works, and gave rise to what we might consider to be the optimal form.

I use between five and six types of clay, including the tokoname and karatsu varieties. Most of the natural clay I use are commonly considered difficult to mold and work with. I use an electric wheel. Each clay type rises differently, and I tend to leave the shape up to the distinctive properties of the clay I happen to be working with. Needless to say, ceramics have traditionally been made to fit the natural clay available in a given geographical region, and local ceramic styles are a product of their environments.

I personally enjoy looking at ceramics from the side.

Bowls, or wan, have their distinctive attractive features, and that has much to do with how beautiful they are from the mikomi, or plan view.[*1] Yet there is also the three-dimensional beauty that they have when looked upon from the side. Both are important. Ryo Aoki[*2] often said that the real test of an utsuwa is above the 180-degree line. From that perspective, it would seem that the essential quality of a bowl lies in its middle, or some kind of golden-mean area. In other words, they are interesting in both their three-dimensional and two-dimensional aspects.

There is something aesthetically comforting to the Japanese sensibility about an object that fits neatly into a pair of cupped hands. The traditional and ritualistic custom of the once-a-day tea ceremony may be a manifestation of this sensibility, where the hands are wrapped around the bowl's form, handling it in a manner almost akin to reverence. In places that use similarly shaped bowls, such as Korea or Vietnam, they do not eat with the bowl placed in the hand, as is the custom in Japan. The bowl, particularly the rice bowl, seems to have a special significance in the hearts and minds of the Japanese. When I ask the young people who come to my exhibitions what they do for a living, many of them tell me that they work in the IT industry. They seem to find the primitive or rustic nature of my work refreshing; taking an essentially shapeless natural clay like clay, and then molding and burning it to make an object with its own distinct use and expression. I imagine they want to keep such objects close at hand in their daily lives for a certain sense of wellbeing and relaxation. I feel that there is a fundamental connection between the form of the wan and the Japanese mindset.

When inspecting a bowl from the side, it is important that the kodai,[*3] or base, touches the surface with sharpness and elegance. The kodai is what holds an utsuwa upright. The shapes formed on the potter's wheel are various, but

YUJI MURAKI
Born 1953 in Yokohama, Japan
Graduated from Tokyo Designer Gakuin College, 1975
Graduated from Seto Ceramics Training School, 1976
Joined Moritoki Otani Kiln, Tokushima Prefecture, 1976
Set up independent workshop in Ito, Shizuoka Prefecture, 1980
Set up climbing kiln, 2010

*1 Mikomi : Refers to the inside of a ceramic container, usually seen from a plan view.

*2 Ryo Aoki : Born 1953. Painter turned ceramist, based in Kanagawa Prefecture. He passed away in 2005 due to sudden illness.

*3 Kodai : The circular base on the bottom of a teacup, bowl, or pot that holds it upright. There are two main types; the kezuri kodai, which is carved out after firing, and the tsuke kodai, which is made from a separate

their figure and appearance depend crucially on the quality of the kodai, in my opinion. Carving a piece that has undergone mizubiki should be left to the next day. The better the quality of the piece spun on the wheel, the more nerve-wracking the process of finishing its base. This is probably due to inflated expectations. I am used to using a shohito to carve out and shave the base, ideally as quickly as possible. However, the process isn't always quick. It is easy to either be too cautious or to overdo it, and I have ruined many a base in my time from getting the balance wrong.

Talking about the "good form" is easy, but it isn't something that is clearly preconceived. In the end, it's all about intention. I initially attempt to create what I intended to create, but the really good pieces seem to be the ones that surpass or transcend those intentions. There are other external and unplanned factors at work in creating a truly great utsuwa.

Teacups are especially prone to become second-rate due to overzealous intent. A good ceramist doesn't consciously think to himself: "I'm going to do a first-rate job here". I do come across some old works that are so magnificent, that the only explanation I can give for them is that some kind of godly power momentarily took over the creative process. When a masterpiece is born, I can't help feeling that there is something fortuitous at work, beyond the consciousness and control of the ceramist. Just a 0.1mm difference in a particular carving can make all the difference. When I look at old ceramics, I might also notice how some glazing has trickled down into a single groove carved into the exterior of the kodai, creating a line in the piece that is just right. Thinking about such details, one is reminded of how infinite the possibilities are for an art form where the piece is completed in a single moment. The works that have stood the test of time and stand out to this day must surely have been made by the ceramist's rhythmic work and mindset on that particular day, combined with some unforeseeable moment of genius or touch from the gods.

Of course, I would count myself lucky if I too could produce just one such work in my lifetime. But for that to happen, I have to keep working and make as many pieces as I can. In any case, the form of the wan continues to fascinate me, and I never get tired of working with it. In fact, I can say that about pottery as a whole.

As a modern artist, Ryo Aoki spent his life grappling with the question of who he was, through his art. It was his way of attempting to find a raison d'être and meaning for his very existence. Another thing he often used to say was how strong people of the past were for their unwavering belief and lack of doubt. He thought people in modern times were incapable of making anything without casting doubt on everything. Take, for example, making a glass water bottle. A water bottle cannot be made as it was in the past, because there is no truth there. According to Aoki, in the modern world, where waterworks have been constructed to send water directly to our homes, it wasn't possible to make a true water bottle anymore.

Looking at the utsuwa he left behind after his sudden departure, I see that they were made with a mighty force and creative frenzy. They are pieces of art more than mere ceramics, and looking back on our time spent together, I am reminded that he was indeed a true artist. I went from pottery school to working for a ceramics company, and eventually set myself up independently, so I started out with the somewhat naïve assumption that I would spend my life making ceramics; plain and simple. We therefore started out from quite contrasting positions; he from a position of doubt, and I from a position of certainty. Yet in the end, our final aim was the same; to try to answer the question of who we were as individuals, and find meaning in our

piece of clay and stuck on with adhesive. This part of a ceramic piece is crucial for research purposes, as it often indicates the country / kingdom of origin, era, kiln, and artisan of a particular work. The teacup developed into an established art form during the Momoyama Period (1573–1603 A.D.), and the custom of focusing on the aesthetics of kodai in particular also began around this time.

*4 Mızubıkı: This is the practice of applying water to clay with one's hands while spinning a potter's wheel to shape a ceramic piece.

*5 Shohito: A small blade made from Japanese pine bark, mainly used to carve out and finely shave the kodai (base) of a ceramic piece.

existence. We influenced each other's thinking, critiqued each other, and through our work, we were able to have a close and honest relationship. That kind of friendship is very rare in life.

Six years have passed since I set up my own climbing kiln. I fuel it twice a year; once in spring and once in autumn. Of course, my experience working with gas-fueled kilns alone is not enough for the upkeep of this type of traditional kiln, and I still feel like a beginner every time. In other words, the more I work with it, the more I discover and come to know just how little I know. There is no end goal in the pursuit of ceramics. With the nearest chamber of the kiln, I have recently made some alterations to my method of firing. This has produced good results, albeit inconsistently. However, wood kilns are very receptive by their nature, and they allow the ceramist to pinpoint precisely how much a particular piece is baked; that is, it gives you a lot of leeway to under-bake or over-bake a piece for a given desired effect. This is the advantage of using a wood kiln. I was particularly happy with the form and poise of the teacup that I made from karatsu clay, a picture of which is shown in this book.

The good thing about karatsu clay is that it is smooth-flowing and doesn't require any extra work to purify. Good clays all have their own unique traits and expressions, and that makes for a wide range of possibilities. Moreover, I think the ceramist's vision goes inevitably beyond his materials. The value of utsuwa is derived from their usage. In a sense, therefore, a piece is not finished by the ceramist, but by the recipient who uses it. When people talk about wanting "individualism" or "originality" in a work, the point is not that you have to make something drastically different from everyone else, but that you should make something that is sincere and true to yourself.

In my years working in ceramics, I have never taken an assistant, and have chosen to do everything myself, from clay making to glazing to firing the kilns. Delegating to someone would simply be too stressful for me. In effect, it's not that I didn't want to do so, but rather that I'm not capable of doing so. Perhaps due to this in part, my passion for ceramics remains the same as when I started out. It's just so much fun. When I speak to younger ceramists, they seem almost overly serious to me. Rather than worrying about whether their products sell or not, or whether they meet the demands of clients, I feel that they ought to focus on first finding out what it is that they themselves want to create; and to enjoy themselves in the process. After all, many Japanese teacups are merely ornamental vessels, and their value is relative. How they are used and valued depends on their owners. The job of the ceramist is to simply make them and then pass them on. Rather than keeping tabs on trends, it is better to do what you feel and make what you truly want. Moreover, what's good or not cannot be determined by just thinking about the problem. The first thing is to keep on making; then, the form will come naturally.

Yuji Muraki's workspace
His studio in Izu, Shizuoka prefecture. He uses natural unprocessed clay.

村木雄児さんの仕事場
静岡県伊豆にある村木雄児さんの工房。使用するのは掘ったままの原土である。

やきものを志した若き頃、粉引に青花の文様を写し、染付の絵を描いていた。たまたま焼成方法を試したなかで、土が見せてくれた表情の変化の面白さに気がつき、器に絵を描くことを止めた。以来、粉引、三島、灰釉など、偉ぶるものから離れ、なんでもない価値のなかで、土ものの器を作り続けてきた。土づくりから釉かけ、すべての工程をひとりでこなし、作陶をおもしろがる姿勢は変わることがない。

　器のかたちというとき、僕のなかで、真っ先に浮かんだのは碗ですね。めし碗と茶碗。やっぱり轆轤が好きなもので、手のなかに納まるかたちというのは、轆轤をひいていても特別なんだ。土取りをして、轆轤をひいて、自分の手のサイズのなかで自由になる大きさということかな。轆轤の途中でも、この線がいいからと、そのまま止めることも思っていた形を変えることも瞬時にできる。自由なんです。めし碗などは、一度に数をひくので、どんどんリズムが出てくる。その途中で、土のなかに含まれる石があったりすると、ちょっとしたことで、かたちに変化が生まれる。意図するところと違う線が生まれ、枝分かれしていくことがあるのです。大きな器だとなかなかそうもいかない。手のなかで包める大きさだから変化が生まれ、ふと、良いかたちが生まれてくる。碗はそういうかたちなんですね。昔の職人も、きまった手順で次から次へ作っていた。小さな心の揺れやノリの良さ、土の状態とか、いろいろあるなかでどんどん作りとばしていくうちに、そこから良いかたちが生まれたのではないかと思うのです。

　僕は常滑の土と唐津の土など、5、6種類の土を使っています。ほとんどが一般には成形が難しい扱いにくい原土と呼ばれる土。それを電動轆轤で成形している。土の立ち上がり方はそれぞれすべて異なるので、かたちは土の性質にまかせるところがある。ごく当たり前のことですが、古来、器とは本来、土に合わせて作るものなのです。産地のやきものの作風はそうして生まれてきたものです。

　器を横から見るのが好きです。碗の見どころはもちろん、上からのぞいた見込みの美しさにある。さらに、横から見た時の立体の美しさがある。その両方です。青木亮*²が器は180度より上での勝負だとよく言っていました。碗のかたちは、その角度でいうと、中間というか、中庸というか。立体と平面の両方のよさがあるから面白い。

　両手で手のなかに納まる心地よさって日本人の心のなかにしっかりとありますよね。一日に一回、お茶を点てていただくのは、手に包む碗のかたちがあって、拝むような精神性なのかもしれない。そういう要素があると思いませんか。同じような器を使う韓国でもベトナムでも、器を手に持っては食べない。日本は手に包んで食べる。日本人にとって最も大切なお米を食べる碗という器にはおそらく特別な意識があるのだろうと思います。僕の個展に来る若い人に職業を聞くと、IT関係の仕事をしている人が多いのですが、彼らにとっては、僕のやっているような、原始的な、なにも形のない土から形を作り、焼き、ある表情を持ってモノが生まれるということがとても新鮮に映り、こうした土ものを身近におきたい、安らぎたいという欲求もあるのではないかと思うことがあります。日本人の深いところにある精神性と、この碗というかたちは繋がっているように思います。

　碗は、横から見ると、高台*³のすっとしたところ、地面に接しているところが凛としていることが大事です。高台は器を支えている部分。その上の轆轤で成形したかたちは、様々であるけれど、それらの姿や佇まい、器のかたちを生かすも殺すも高台であると僕は思う。

　轆轤で水引き*⁴した器を削るのは次の日の作業です。うまく轆轤がひけた器ほど高台を削るのが緊張する。欲が山ものだからね。使い慣れた松皮刀*⁵で一気に削る。いや、それは理想。一気に削りたいのだけれど、そうはいかない。躊躇したり、やりすぎたりして、良いかたちを台無しにすることが多い。

　良いかたち、と言ったところで、実は明確に見えているわけではないんだ。結局、意識なのでしょう。意識してかたちを作るのだけれど、ほんとうに良いものはその意識を超えたものなのかもしれない。別の要因でできてし

村木雄児　YUJI MURAKI
1953年　横浜市に生まれる
1975年　東京デザイナー学院を卒業
1976年　瀬戸窯業訓練学校を卒業
1976年　徳島県大谷焼森陶器に入社
1980年　静岡県伊東市にて独立
2010年　登り窯を築窯

まったかたちが確かにあるよね。

　とくに茶碗はその気になったものは大抵だめだね。職人はうまくやってやろう、とか思っていない。昔の物でたまたま神様が宿ったとしか思えないものがある。とんでもない名品が生まれたりするのは、作り手の意識を超えたものができてしまったのではないかと思えてならないのです。削りが0.1ミリ違っても違うのだから。古いやきものを見ていても、高台の外側に削られた一本の線に釉薬が流れて程よいラインを作っていたりする。そのことを考えだしたら、一瞬に出来上がるかたちは無限でしょう。いま名品として残っているのは、きっと、作り手が「今日は調子良いなぁ」と思ってリズム良く作ったものに神様がそっと手をくわえたんじゃないかな、なんて思います。

　もちろん、僕も一生のうちにひとつでも、そんなものができたらなと思うけど、それには作りとばして、数作らないといけないと思うんだ。それにしても碗はほんとうにおもしろい。作っていて飽きることがない。やきものってそうだよね。

　青木亮は現代美術家として自分とは何者かを作品に問い続けてきた作り手です。作ることで自分が生まれてきた意味を見出そうとしていた。それと繰り返し言っていたのは、昔の人間の信じて疑わないことの強さについて。現代人は何も疑わずにものを作ることはできないんだ、と言っていた。たとえば、瓶のかたちを作る。でも、もう昔のようには作れない。なぜなら、そこに真実がないからだ。水道完備の現代の人に水瓶を作ることはできないんだと言っていたね。

　彼が急逝し残された器を見ると凄まじい勢いで作られたものだと感じる。それらの器は器というより作品であり、いま振り返っても、しみじみ作家だなぁと思う。僕は窯業訓練校から陶器の会社に就職したのちに作家として独立したので、案外最初から、疑いも持たずに器を作るようなところがあって、疑うことから始まった彼と信じることから始まった俺、たがいに違ったところから出発しているんだけど、目指すところは同じ、結局、自分はなんだろうということ。互いに刺激しあったり、批判をしたり、ものを通じて、本音で付き合えた。なかなかないんだけれどね。希有だと思いますよ、あいつとは親友になれた。登り窯を作って6年になります。春と秋に二回のペースで窯を焚いている。これまでガス窯で培ってきた経験だけでは当然ながらだめで、毎回、初心に戻る。いかに自分がわかっていなかったかがわかる。それを発見するようなものです。器づくりにはこれで終わりというのがない。直近の窯では、焼成の方法を少しこれまでと変えてみたんです。うまくいったものとそうでないもの、半々の仕上がりです。ただ、薪窯はもともと包容力のある窯で、ピンポイントでこうしたものを目指したいと思った焼き上がりの、前後、つまり、焼き過ぎたものと手前のもの、両方とれる。薪窯の懐の深いところです。この本に掲載の唐津の土を使った茶碗のかたち、佇まいは気に入ったものです。

　唐津の良いところはさらりとして余計なことをせずに潔いところだと思っています。良い土はそれぞれ癖や表情を持っていて、それが成り立つ。その向こうに見えるのはとても深いものだと思うんですよね。器は使われてこそ価値がある。器を完成させるのも自分ではなくて、他者に委ねるしかない。皆、個性と言うけれど、それは人と違うものを作らなくてはならないということではなくて、自分が素直にでたものなのではないかと思う。

　これまでアシスタントもとらず、土作りから釉かけ、窯焚きまでひとりでやってきた。助手に仕事を渡そうとすると、それを考えなくちゃいけないでしょう。それが面倒で。人に任せることをしなかった、と言うよりできな

*1 見込み：茶碗や鉢の内側の部分。おもに茶碗を覗き込んだところをいう。

*2 青木亮(Ryo Aoki)：1953年生まれ。美術家を経て陶芸家。神奈川県にて作陶。2005年、突然の病にて逝去。

*3 高台：茶碗・鉢・椀などの底にある輪状の基台。轆轤成形後に削り出す削り高台と、粘土で成形して後で貼付ける付け高台とがある。国・時代・窯・作家に特長が出るので考証に重要とされる。桃山時代に入り、茶碗の創作性が問われるようになり、高台観賞が習慣にされるようになった。

*4 水引き：水を含む手で轆轤をひき、かたち作ること。

*5 松皮刀：松の皮で作った小刀。おもに器の高台の削りに使用する道具。

かった。そのおかげかどうか、器を作ることへの情熱は衰えない。楽しいんだ。30代くらいの作り手と話すと、みんな真面目だなあと思います。売れるとか、期待にこたえるとか、そんなことより自分がやりたいというものをまず作ってみたらいいと思う。まず面白がること。茶碗だって、その多くは、もともとは見立ての器です。どんなふうに使ってもらうのかは使い手が見つけてくれる。我々作り手は、作り、そして手渡していくことが仕事なんだ。流行ばかりではなく、自分の想いで作ってみて、何が良いのか悪いのか、考えてばかりでは答えが出ないから。まずは作り続けていく。かたちは自ずと生まれてくる。

Karatsu teabowl by Yuji Muraki | φ: 14.3cm H: 8.1cm

CERAMISTS INTERVIEW

YAKU MURAKAMI

村上躍

After majoring in design at Art College, he became an artist that works with clay by hand. The method he uses is handbuilding with which he creates highly functional pieces such as teaware, that have beautiful well-honed lines and offer a unique view of the world.

I create most of my ceramics using the handbuilding technique. Although I did study other methods such as the potter's wheel and casting, the graduation work was a handbuilt ceramics. Why do I use the hand-building technique – it could be because the way I interact with clay until the piece is complete, or the process necessary to achieve this suits my rhythm.

There is hardly any contradiction between the process of assiduously creating by hand and something that flows within me. I think that for myself, the pace of throwing clay on the potter's wheel is probably too fast-paced.

I first envisage the form in my head. I draw this onto a piece of paper. Then I start forming the shape with the clay in front of me. However, I do not form the shape that I envisaged straight away. I create a three-dimensional from a two-dimensional, but no matter how hard I try, many a time it ends up not bearing a resemblance to it. What I think in my head is only something that provides a spark. The process involves not recreating what was envisaged, but creating a blueprint by hand, through forming with the hand. These forms are constantly changing.

I was told that Sori Yanagi created his forms using a plaster cast and then asked manufactures and craftsmen to make them. I do the entire process by myself. In other words, inside of me there lives a designer and there also lives an artisan who uses his hands to actually create the form. The designer in me says I want to do it this way, and then the artisan in me says, no that is not possible. There is an internal debate going on. I enjoy the process, there is no pressure and it is fun. Of course in my case, I do not create a form using a plaster cast. I build the shape directly with my hand. There are somethings that the plaster cast can achieve that is not possible just using clay.

I am not attached to any particular clay. What I am using is called Shigaraki Clay, and can be obtained easily anywhere. I select clay that have the ability to create what I want. I use this clay because it is easy to work with. Although I start with a design, the form I want to create continuously changes, and that is what makes it interesting. A new discovery can be made through forming with the hand. In fact, after a shape is formed, sometimes this can be a starting point and it can become transformed into a completely new shape. The lengths may change or the angles may alter. Many a time, I end up with a variation of the form I started off with.

Which is my favorite form? I so sometimes feel a sense of excitement from the pieces I have made in the past. However, because I am continuously creating, I could say that what inspires me then turns into the newest piece. Ultimately, I am endlessly seeking and creating new forms.

What are shapes? That is not an easy question to answer... it probably is not possible to express this in words. I believe that a shape is something that you feel. It is extremely vague and hard to articulate. Although it cannot be verbalized it can be touched, seen and felt. It is real, and it has certainty.

For example, there is a form that you think is "good". Conversely, when you are asked why you think it is good, although you can judge that you like it, it is not easy to explain as to why? But although these senses are ambiguous, they are also definite. In other words, you can tell the difference when you compare. When there are two extremely good ones, and they are similar but yet dissimilar you can tell which one you prefer. Such as you like this angle or this width and balance is better and so on. If you have an object of comparison, you may be able to put into words which one you favor. However, the merits and demerits of a shape of a creation cannot be explained in isolation. These things have to be felt.

Even with the same form, the glazing and engobing,

YAKU MURAKAMI
Born 1967 in Tokyo
Graduated from the Musashino Art University Junior College of Art and Design, Advanced Course, 1992
Begins producing works as a molding artist
Begins creating ceramics, 1998
Currently works as a ceramist in Kanagawa

the vessel changes expressions. I have some people describe my work as superficial, technical or decorative, but for example after engobing the process of leaving a subtle hint of white slip while wiping it off with a sponge is necessary, in order to express the fine details and strong presence of the piece.

I try not to create pieces with the same form on the same day. I do not want my work to turn into just a predictable operation and therefore I try not to get my hands used to the movement. If I apply routine procedures, I may be able to produce more numbers and will lead to the streamlining of the production process. However, my wish is to create pieces as an artist no matter how inefficient it may be, and want people to see my pieces that have been produced in that way.

I create about two hundred pots and teapots every year. The most important thing is to ensure that the piece has a presence as an object like your other works. Whether the shape and texture can demonstrate dignity and appearance that is worthy of appreciation. Of course I am conscious that the people who like my pots are strongly seeking its functionality as a utensil. Some may think that the "beauty of use" is the result of refining its functionality as a utensil which leads to the formation of a naturally beautiful contour. I am skeptical as to whether the journey to reach true beauty can be so simple. I believe that this requires a keen sense of aesthetics, the skill to turn ideas into reality and a sense of self-discipline to look at oneself objectively. What must be considered is how to balance the aforementioned dignity and appearance with the functionality as a utensil at a higher dimension.

As a child, I liked drawing shapes of objects. I used to find small insects and draw them. Me and my brother would open an illustrated encyclopedia together and point at things and try to draw them. That was my favorite pastime.

Everyone draws pictures as a child. Or they may like to sing and dance. Children can express themselves in the most natural way as they interact with the world around them. Singing and dancing are a way of expressing one's inner self by exploring and assimilating our surroundings. In my case, drawing was my way of expressing. As I reflect back, I notice that my act of creating a vessel is no different to myself drawing as a child. When you ask yourself why you create something, you become aware of the fundamental reason. Needless to say, I am blessed with the opportunity for self-realization through making ceramics. I create ceramic pieces as an artist and then offer them to the people who use them. I am who I am through someone receiving what I have made, and I am always appreciative and thankful for that. However, purely giving to people, is secondary.

Even if I went to live on a desert island where no one is around, I think I will still keep on creating things. I will still create things even in a world where I am all alone. Although I create ceramics to make a living, if I were to ask the fundamental reason why I create, it is because it is the way I express myself. This is the way I interact with the world around me.

I think that what makes a shape beautiful is not the boundary of the shape itself, but rather the atmosphere that surrounds it. Rather than chasing the last point by trimming down the shape, I think there is more beauty in the remaining space and margin. Isn't this the case with music? The significance of the music piece lies in how rich the silence is between the sounds. The same can be said about painting. Take the "Shorin-zu Byobu (Pine Trees)" of Hasegawa Tōhaku for example. What is actually more important is not the pine that is painted using thin ink, but the white space that has nothing drawn on it. The beauty of the art is influenced by how much space with nothing painted on it exists. The purpose of black line is to complement the

* Sori Yanagi: Munemichi Yanagi (Real name), 1915-2011
Born in Tokyo. Graduated from Department of Western Arts, Tokyo National University of Fine Arts and Music (present-day Tokyo University of the Arts). Established Yanagi Design Office in 1952. He was a leading figure in a variety of fields in the industry design arena such as tableware, cutlery, furniture. Son of Sōetsu Yanagi (also known as Muneyoshi Yanagi).

space. I think for those who create shapes into a 3D form, this is something we are expected to be better aware of. In other words, the existence of resonance can be depicted in shapes. When I create, it is vital to envisage the space that the piece is going to be placed.

Although texture, line and angles are all important individually, I think what is crucial is that they complement one another. The part and the whole, there are subordinate-superior relationships between them, and each exist on their own merits, and are in a harmonious and complimentary existence. To create something that resonates with the space surrounding it. That is my job.

Vase, Sand make up by Yaku Murakami | φ: 31cm D: 18cm H: 9cm

Ceramist, Yaku Murakami's hands.
He slowly places handle, spout, and tea strainer inside the round body.

村上 躍さん作陶の手
丸いかたちのボディに注ぎ口、取っ手、内部の茶こしを時間をかけて作っていく。

美術大学でデザインを学んだのち、手を道具として土でかたちを作る作家となった。制作の方法は手捻りである。茶器をはじめとして極めて機能に優れているそれらの作品は、研ぎすまされた美しいラインをもち、独自の世界観を感じさせる。

ほとんどの器を手捻りで作っています。大学では轆轤や鋳込みなどのほかの手法も学びましたが、卒業制作で作った作品も手捻りの器でした。なぜ、手捻りで作るのか。あえて言うなら、作品ができるまでの土との関わりかたや、そこに到達するまでに必要なプロセスが僕のリズムとあっているからでしょうか。手でこつこつと作ることは、僕のなかに流れているものとの齟齬が少ないのです。轆轤で成形する方法は、きっと、僕には、かかる時間が早すぎるのだと思います。

　かたちは、まずは自分の頭のなかで描きます。それを紙のうえで描いてみたりする。そして実際に作り始めます。ただし、頭に描いたかたちをそのまま作るわけではないのです。二次元から実際に三次元に作っていくのですが、頭のなかで考えたものに近づいていこうとしても、結果、たどりつかないことが多いですね。頭で考えていることは、きっかけに過ぎません。頭で描いたかたちを再現していくのではなく、実際に手を動かして、手で設計図をひいていく。それらのかたちは常に変化していくのです。柳宗理さんは石膏を用いてかたちを自分で作り、メーカーや職人に発注していたそうですが、僕は、その作業をひとりでやっているようなところがあります。つまり、デザイナーとしての自分と、手を動かしかたちを実際に作っていく職人的な自分がいる。デザイナーの自分がこうして欲しいと言う、すると、職人の自分がいや、それは無理だ、と。そんなやり取りを自分のなかでしているのです。その作業は無理がなく、楽しいものです。もちろん僕の場合、石膏でかたちを作ることはありません。ダイレクトに土で作っていくのです。そもそも、石膏では可能でも土ではできないこともあるのですから。

　土にこだわりはありません。使っているのはすべて信楽の土で、どこでも手に入るような土です。あくまで僕が作りたいものを作ることができる能力のある土を選んでいるということです。その土が作りやすいから使っています。作りたいかたちはデザインが最初のスタートとしてあっても、どんどん変わっていくから面白いのです。実際に手を動かすことで、新しい発見がある。実際、かたちが出来上がった後、またさらに、それを出発点として、新たに違うかたちが生まれることがあります。長さを変えたり、角度を変えたり。自分が作ったかたちを起点として、バリエーションが生まれてくることが多いですね。

　これまで気に入ったかたちですか？過去に作ったもので気持ちが高揚した瞬間はありますが、いまも現在進行形なので、その都度、新鮮に感じて最新作に至るということでしょうか。つまり、いかなるときも、かたちを探し、作り続けています。

　かたちとは何か、なんて答えるべきでしょうか。それはとても難しい。……そうですね。やっぱり言葉に置き換えるのは無理ですね。かたちとは感覚的に感じるものかなと思います。とても曖昧で、言語化できない。言葉にすることはできないのだけれど、実際に触れたり、見たりして、これだと感じることはできる。リアリティがあり、確かなものなのではないかと思います。

　たとえば、いまの自分が「これがいい」と思えるかたちは存在している。けれども、なぜと問われても、好きだと判断することは可能でもそれを上手に説明できないものでしょう。しかしそれらの感覚は、曖昧なのだけれど、確定しているものでもある。つまり、比較するとわかりますよね。とてもよいものがふたつあったとして、似ているけれど異なるふたつを比較することで、どちらが好きかは答えることはできる。この角度がいいとか、幅とのバランスがいいとかね。比較対象があるとどちらがいいか、ということは言葉にできるかもしれない。しかし、もののかたちの

村上 躍　YAKU MURAKAMI
1967年　東京都に生まれる
1992年　武蔵野美術大学短期大学部専攻科卒業
　　　　造形作家として制作発表を始める
1998年　陶器の制作を始める。現在神奈川にて作陶

善し悪しというのは、単独では説明することはできない。それは感じるしかないものです。

　かたちは同じでも、釉薬、化粧掛けの方法で、器の表情を変えています。僕の仕事を表面的で技巧的、あるいは装飾的だと言われたこともありますが、たとえば白化粧をかけたあとでそれをスポンジで拭い落とし、微妙に化粧土を器の表面に残すようなことは、ディティールや佇まいを表現するのに必要な工程なのです。

　同じかたちを日にいくつも作らないように心がけています。仕事を作業にはしたくないので、手が慣れないようにしているのです。ルーティンにすれば効率はよくなり、数も増え、制作を合理化できるのでしょうが、非効率でも、作家として作品を作りたいし、そうして出来たものを見てもらいたいのです。

　年間でおよそ200点ほどのポット、急須を作っています。最も大切なのは、他の作品と同じくモノとして自立する存在感を持たせること。形、質感とも、鑑賞に耐えうる品格や佇まいを持たせられるかということです。もちろん僕のポットを求める方が、道具としての機能性を強く求めていることも理解しています。「用の美」とは、道具としての機能性を突き詰めて行けば、おのずとあるべき美しいかたちへとたどり着く、という考えだと思いますが、僕は、本当の美しさへたどり着く道は、そんな単純なことではないと思っています。鋭い美的感覚と、理想をかたちにする技術、そして自分を客観視できる冷静さが必要だと思います。先に述べた品格や佇まいと、道具としての機能性を高い次元でどう両立させるかを考えなければならないと思います。

　図鑑を見ながら、もののかたちを写すことが好きな子供だったんですね。小さな虫を見つけて描くことも多かった。弟と一緒に図鑑を開いてページのなかのものを指差して、ありとあらゆるものを描きっこする。その遊びが好きでした。小さいころは誰でも絵を描きますよね。あるいは歌だったり、踊りだったり、自分と世界との向き合い方として、子供は自然に自己表現をする。歌や踊りは、まわりのものを咀嚼して、自分の内側を表現する行為です。僕の場合、それは絵を描くことだったのです。いま思うと、器を作っていることは、子供のそれと変わりがないことに気がつきます。なぜものを作るのかを問うとき、根源的な理由につきあたります。もちろん僕は器を作ることで自己実現の機会を得ています。作家として、器を作り、それを使う人に届けている。作ったものを誰かに受け取っていただいて、いまの僕があるのです。そのことはいつも感謝していますし、とても大事なことなのですが、突き詰めていくと、それは二次的なことだと思うことがあるのです。

　仮に無人島に行って誰もいない状況になったとしても、やはり僕は、ものを作るだろう、と思います。ひとりぼっちの世界においても、僕はものづくりをする。生きるための糧として器を作っているけれども、根源的な意味を問われるならば、僕は僕自身のありかたとして、ものを作るとしか言いようがない。それが、僕の世界との向き合いかたなのだと。

　かたちの美しさを作るものは、実は、かたちそのものの境界線のラインではなく、それを包む気配のほうだと思っています。かたちを削ぎ落とし最後の一点を求めていくよりも、むしろ、美しさとは、残された空間、余白のほうに意味があるのではないでしょうか。音楽もそうですよね。音と音の間の無音のところにどれだけ豊かなものがあるのか、そこが大切です。絵画も同じことが言えます。長谷川等伯の松林図屏風を例にとっても、薄墨で描かれた松よりも、何も描かれていない余白のほうが実は重要

* 柳宗理　Sori Yanagi　本名：Munemichi Yanagi　1915年－2011年
東京に生まれる。東京美術学校(現東京芸大)洋画科卒業。
1952年(財)柳工業デザイン研究会を設立、以後、食器、カトラリー、家具など、インダストリアルデザインの第一人者として多岐にわたり活躍。父は柳宗悦。

で、どのくらい描かれていない空間があるのかによって、作品の美しさは変わってくる。空間を引き立てるために、黒いラインがある。三次元にかたちを作っている僕たちもそのことを意識したほうがいいんじゃないかと思いますね。つまり、かたちは、余韻をふくんでいる。そのものが置かれる空間を想像することが僕の制作には欠かすことはできません。

　かたちも質感も、ラインも角度も、それぞれ部分も大事ですが、お互いに補充し合っていることが肝要と思います。全体と部分、そのどちらかが主従関係ではない。それぞれの存在が立ち、しかも、補い合い調和していることが大事なのです。まわりの空間と作品が響き合うものを作る。それが僕の仕事だと思っています。

CERAMISTS INTERVIEW

ATSUSHI OGATA
尾形アッシ

Interested by kohiki—an enjoyable technique of dipping a red clay body into a slip mixture and likened to adorning a cloth on a body, he continues to make ceramic vessels. He specializes in making simple and powerful statement pieces. In recent years, he has been focused on making vases and large jars which are fired in a wood-fired kiln.

I believe the form of a piece is a representation of the ceramist. Usually, the form is always on the ceramist's mind. Whether, it is lines, the mouth, or the inner surface. The ceramist will pay attention to any variations which stand out. They will work on it while self-questioning themselves as to whether the form will appeal to and resonate with the public. I believe when we first see a piece, the form draws us in and then we are compelled to look at and touch it. In other words, while the form represents the face and personality of the ceramist, it is also the initial introduction. We all have different faces; similarly, a piece can assume many different forms which are a reflection of a ceramist. In our pieces, the ceramist's individuality is apparent. A rice bowl can be shaped into various forms, depending on who made it, even though it is essentially a rice bowl made of the same clay with the exact same composition of glaze. However, bowls are not finished in the same way. They are never identical.

I use natural clay, otherwise known as unprocessed clay. Initially, I was surprised at how difficult it was to work with and shape forms. But I also discovered that the pieces came out with characteristics that would not be possible with refined clay. This experience made me realize, while refined clay is easier to use and mold, real quality resides in natural clay. The more difficult the clay is to work with, the more personality or quality emerges. With this in mind, I searched for natural clay. That being said, natural clay is not always good. In some cases, my efforts were heedless, as neither the style nor variations I sought appeared on the pieces. Simply using natural clay does not always guarantee the characteristic results I want.

Red colored clay, better known as red clay, contains plenty of iron. There are said to be red clay deposits all over Japan. This rather ordinary type of clay is used to make clay pipes or tiles. With some care given to the clay, it is possible to use it to make ceramic vessels. I mainly use natural clay from the Iga district mixed with five or six other types of clay to make my pieces. I also use the clay as a slip when performing decorative techniques called kohiki and hakeme or brushmark slip - painting the body with slip and leaving brush marks.

Typically, Western ceramics are the result of high firing a red clay body. Though there are other glaze techniques, I use kohiki. Kohiki is a technique of coating a red clay body with a thin layer of white clay which is also referred to as slip clay. Through this process the red clay body becomes glazed in white. These white slip pieces are widely sought after, all over the world.

Whenever I find new clay, I fire the clay without glaze, and then experiment with different types of slip. The process of combining clay and slip brings forth unexpected and refreshing characteristics.

Seven years ago, I built a wood-fired kiln. My intention was to fire my own pieces in my own kiln. However, it is not easy to fire pieces and get results the way you imagined. If I wanted to reproduce ceramics, such as Karatsu or Koshigaraki, I would build a kiln to fire such kinds of ceramics; however that is not my objective. With the expectation that I would be able to make better pieces, I replaced a gas-fired kiln with a wood-fired one. Needless to say, it was not that simple. A timely struggle ensued to improve the kiln, where I repeatedly had to fire clay and examine the results. After this endless period of trial and error, I was able to identify certain tendencies and variables of the kiln. Additionally, I grew aware of a certain pattern of conditions that helped me to predict the performance of the kiln and how the clay would bake. I have used the experience and data I collected to improve my process, which have helped me to get a little closer to the results I wanted to achieve.

ATSUSHI OGATA
Born 1960 in Tokyo
Graduated from Aichi Prefectural College of Ceramic Engineering, 1996
Set up independent workshop in Seto, Aichi Prefecture, 1998
Moved to mountain valley in Uda, Nara Prefecture, 2007
Set up downdraft wood-fired kiln, 2009

For example, during the process of firing kohiki in a wood-fired kiln, I noticed something. I wanted to get a higher concentration of white; instead I ended up with many other variations and colors, such as pink or white with blue tones. Although they were not the pure white that is sought out in the process of kohiki, they were attractive with rich and deep characteristics and variations. Driven by this discovery, I began to use various types of clay as a slip over the basic white slip. I made pieces using clay slip in order to highlight the genuine quality of the clay. Originally, the white slip came about to achieve a white finish on a red clay body. I feel that pieces covered with clay slip are adorned with simple robes and there is true quality in that. In any event, my day to day job involves playfully seeking out interesting characteristics which have never been seen before through kohiki.

Although it is still the early days, I have finally been successful in firing a vessel painted with hakeme brush marks in a wood fired kiln. I have tried various kinds of glaze in combination with many different firing methods. Through this experimental process which required patience and consistent effort, I feel that I am heading in the right direction, just like climbing up the stairs, one step at a time.

Using a wood fired kiln has brought about among other things the opportunity to make jars. I have had experience firing a large jar in a gas-fired kiln, but I found remarkable characteristics emerge when jars are fired in a wood fired kiln. For better or worse, the results could be beyond ceramist's expectation, in some cases much more interesting than what the ceramist imagined. It is almost like painting a mural on the jar with the flames of the wood fired kiln, therefore it is interesting and a little addictive.

Initially, I built a wood fired kiln because I wanted to make ceramic plate ware. But the ashes from the firewood created strong characteristics which made me conjure up the idea of firing larger plates, jars and pots, as they are more suited to wood fired kilns. Now, I want to make a jar, far bigger than what I have previously made, that has involved revamping the structure of the kiln, twice.

It is impossible to make a large jar quickly; it is a slow painstaking process to get the right form. A method called coiling is used to make large jars. A wall is built by coiling ropes of clay and dried from the bottom to the top in order to gradually establish the desired height. Dryness and strength must be considered, as they vary depending on the type of clay. I once saw a craftsman completing a jar on the potter's wheel in one burst. He lifted up fifteen kilograms of clay and built a jar as high as fifty centimeters in five minutes, "hats off" to that craftsman. I am not there yet and I still pile clay slowly but surely.

I like simple jars with plain forms. Yayoi earthenware (made during the Yayoi Period. 3rd century B.C.- 3rd century A.D.) is a good example. They are shaped in simple and economic forms because they were made for daily use. I like their beautiful curves. The form of a jar is determined by the following: bottom diameter, width of girth, height and size of the mouth. I want to make a jar in which those elements are beautifully combined while also maintaining good balance. Though, jars produced during the Joseon Dynasty have elegant curve lines with good balance, they are slightly crooked, resulting in an exquisite fluctuation. I aim to achieve that kind of quality. The jars were not made crooked intentionally or on purpose, it happened naturally. This is such an interesting aspect. I feel intrigued by these remnant fired objects.

It takes a great deal of effort to fire a large jar. In particular, when trying to get rich characteristics, a possible crack on the jar is a necessary risk. The larger the jar, the greater risk. It depends on the temperature difference, the

* Koshigaraki: Shigaraki old ceramics. Jars and miscellaneous ceramic vessels made during the Kamakura (1185 – 1333 A.D.) and Muromachi Period (1336 – 1573 A.D.).

angle of the flames and the weight of a jar. Completing a jar without any damage is an extremely difficult undertaking. However, the ash creates characteristics that are very attractive even if there is a crack or some damage. I once exhibited a large jar which had cracked in the firing process; the public had a strong reaction to it. Since then, I embrace such flaws even cracked pieces, as they reflect many of the characteristics that emerge in the kiln and such damaged parts can be at times highlighted with lacquer.

After the firing process, the kiln is left for a few days to cool down and it is then time to take out the pieces. In that first moment, my eyes see the unfired jar. It has been in strong flames and coated with ashes. Rich and intricate expressions are unveiled in front of my eyes. Now, I would to make a large hakeme jar. I aim to create pieces with strong characteristics and presence.

Big jar with natural ash glaze Brushmark slip by Atsushi Ogata | φ: 37cm H: 43cm

赤土に様々な化粧土を施し、土に衣を着せていく粉引の仕事の面白さに惹かれ、器を作り続けている。味わい深く土味（つちあじ）が生かされた素朴で力強い器を得意とする。近年は薪窯の火前で焼成する花器や大壺の制作に取り組んでいる。

かたちとは、作り手自身だと思いますね。作り手は、基本的にかたちのことばかり考えているものです。ラインだったり口元だったり、見込みだったり。目に飛び込んでくるかたちを見て、何か心に響くものはないか、訴えるものはないかと、自問自答しながら、作家は器を作ります。人は器を見たときに、まずかたちに興味を持ち、触りたい、見たいと思うのではないでしょうか。つまり、かたちとは入り口なのです。そして作り手の顔、個性だと思います。ひとりひとりの顔が違うように、そのかたちというのは、作り手自身を投影している。僕たちの作る器には、作り手がそのまま現れてくるのです。めし碗ひとつにしても、用途的にはボウルのかたちですが、同じ土、同じ配合の釉薬で作っても、当然ながら出来上がったかたちは作り手によって、あきらかに違ってくる。それらはすべて同じではないのです。

　土は天然のいわゆる原土と呼ばれるものを使っています。最初に原土を使ったときに、その扱いにくさと作りにくさに驚きました。しかし、それを焼き上げたときに、精製した土では絶対に出ないような表情がとれたのです。精製することで、使いやすさ、扱いやすさと引き換えにしているものがあることに気がつきました。扱いにくい土ほど、土の個性がたくさん含まれています。その実感があって、土を探します。しかし、原土だから良いということでもない。苦労して自ら採取した土をそのまま使いても、味わいが出ない土もある。原土だから表情が出るということでもないのです。

　いわゆるレッドクレイと呼ばれる赤土は、鉄分をたくさん含んでいる土です。この土は日本のどこにでも産出する土といわれています。土管や瓦を作るありふれた土ですね。その土に手をかけることで器を作ることができる。僕の場合は、伊賀地方の赤土をベースに、5、6種類の土を使って器を作っています。粉引や刷毛目はそれらの土を使っています。

　赤土をベースに考えていくと、その土を生かしたやきものは焼き締め、南蛮になります。僕は釉薬ものをやってきたなかで、粉引を選んできた作家です。粉引というのは、赤土に白い土を薄くかける技法です。この薄掛けされる白い土は、化粧土ともいわれます。粉引とは、化粧をすることで赤土を白い器に変えるもので、白を基調としたそれらの器は、世界中で広く求められているものです。

　新しい土が見つかると、最初は釉掛けをせずに、無釉で焼きます。そして次に様々な化粧をかけて実験をするのです。土と化粧が組み合わされることで、土は思いがけない面白い表情を見せてくれることがあります。

　薪窯を作り7年が経ちます。目指しているのは僕なりの作品を薪窯で焼くことですね。頭で描いたものが簡単に焼けるわけではありません。もし僕のなかに、明確に唐津や古信楽を復元したいという希望があれば、その目標に合わせて窯を作っていけばいいのですが、目指しているのはそういうことではないのです。薪窯を作った頃は、自分がこれまでガス窯で焼成してきた器がより良いものになるだろうと思っていたのです。しかし、そう単純ではない。毎回窯と格闘し、焼いては窯出しすることを繰り返すことで薪窯の癖を見抜き、そしていくつかの状況下でどういう条件が揃えばこういう器が焼き上がるというデータを積み重ね、改良を重ねてきた。そのお陰で、いまでは自分が思ったものが少しだけとれるようになってきたところです。

　たとえば粉引を薪窯で焼成していて気づいたことがありました。白さを求めながらも、薪窯では様々な色や表情の器が焼き上がってきます。ピンクや青白くただれ

尾形アツシ　OGATA ATSUSHI
1960年　東京都生まれ
1996年　愛知県立窯業高等技術専門校卒業
1998年　愛知県瀬戸市に工房を構え独立
2007年　奈良県宇陀市の山里に移転
2009年　倒炎式薪窯を築窯

　た焼き色は、本来の粉引が求めている白色ではありませんが、その表情は深く、変化に富んだものがいくつもあり、魅力を感じました。それからです。白い化粧土だけではなく、さまざまな土を化粧として使うようになったのは。土の持ち味がより良く伝わるようにとの思いで、土化粧の器の制作を始めたのです。本来、白い器に憧れ、白い衣を着せることから始まった白化粧ですが、土化粧という土味のままの野良着のような素朴な力強い器もまた、真実なのではないか、と思っています。いずれにしても僕の仕事は、日々粉引という表現に向かうことです。いままでにない表情を引き出したい、その面白さを追求したいと思っています。

　一方、荒い表情の刷毛目の器は、やっと薪窯で成功するようになりました。土や釉薬を変えたり、焼き方を変えたりすることで自分の目指す方向に近づいていきました。その過程は階段のステップみたいなものですね。少しずつステップアップしていくしかない、地道なものです。

　薪窯が僕にもたらしたことのひとつに、壺の制作があります。ガス窯では何度か大壺を焼きましたが、薪窯での表情は別格なのです。良い意味でも悪い意味でも、作り手の想いを超える面白さがある。大壺は薪窯の炎で描く壁画のようなもので、ちょっと病み付きになる面白さがあります。

　当初僕の薪窯は、食器を中心に焼くために作った窯でしたが、火前は灰の強い表情がつくため、食器よりも花器に向いていることに気がつきました。そうして次第に大皿や壺を火前で焼くようになったのです。さらに大きい壺を焼きたいと考え、火前の窯の構造を二度程作り変え、現在にいたっています。

　大壺は一気には作れないもので、かたちを作ることに苦労します。紐作りの手法で土を紐状に積んでいき、積んだ土台部分を少しずつ乾燥させ、次第に高く、大きくしていきます。土によって乾燥度合いや強度が違うので、土の特性を考慮しながら作らなくてはなりません。以前、韓国で大壺を轆轤で一気に作る職人を見たことがありますが、15キロの粘土玉を引き上げ、五分程で高さ50センチの壺を作る姿に脱帽した思いがあります。まだ私には、その力はありません。ゆっくり、確実に、今日も土を積み上げます。

　壺のかたちは、素朴なものが好きですね。たとえば、生活の道具として使われていた弥生土器のようなものは、かたちに無駄がありません。柔らかな曲線がとても美しいと思います。壺のかたちは、底の径、胴まわりの幅、高さ、そして口の大きさで決まります。このバランスがとれていて、美しく、繋がっているものを作っていきたい。李朝の壺は、見事なバランスと美しい曲線を持ちながらも、わずかに歪んでいたりするその揺らぎが絶妙で、自ら目指すところのひとつです。作り手が故意に歪めたのではなく、焼きのなかで、壺が自ら傾いたりするのが、面白いと思うのです。この、焼かれた痕跡みたいなものに惹かれるのかもしれません。

　大壺は焼くのも大変です。特に、火前で豊かな表情をつけるには、割れる覚悟が必要です。大きければ大きいほど、炎の当たり方による温度差、壺自らの重みなど、リスクは格段に上がり、傷ひとつ無く焼き上げるのは、至難の技です。ただ、傷や破れがあっても薪窯での灰を被った表情には、独特の魅力があるものです。以前、火前で割れた大壺の姿をギャラリーで展示したことがありました。その有り様は訪れた多くの方々にインパクトをもって受け入れられました。それ以来、たとえ割れた壺であっても窯のなかで作られた表情のひとつとして傷を生かし、漆で継いで作品とするものもあります。

＊古信楽：信楽焼の古陶。鎌倉時代から室町時代にかけて焼かれた種壺・雑器をいう。

　窯を焚き終え、数日冷ました後、窯出しをします。そのとき最初に目に入るのが、火前の壺です。強い炎のなかで焼成された壺に自然の灰が被り、流れ、複雑で豊かな表情が目の前にあらわれる瞬間です。これから焼きたいのは、刷毛目の大壺ですね。土味の出た強い存在感のあるものを目指したいと思っています。

PHOTO：ATSUSHI OGATA

Kohiki rice bowl by Atsushi Ogata | φ: 12cm H: 5.5cm

碗 Bowl

9	吉田直嗣	白磁鉄釉碗	φ 13.6cm H 9cm
		Bowl, White porcelain with iron glaze by Naotsugu Yoshida	
10	寒川義雄	粉引めし碗	φ 11cm H 6.3cm
		Kohiki rice bowl by Yoshio Kangawa	
11	荒賀文成	粉引めし碗	φ 13cm H 6.5cm
		Kohiki rice bowl by Fuminari Araga	
12	寺田鉄平	織部めし碗	φ 13cm H 5cm
		Oribe rice bowl by Teppei Terada	
13	森岡成好	黒釉めし碗	φ 12.5cm H 6cm
		Rice bowl with black glaze by Shigeyoshi Morioka	
14	村木雄児	三島めし碗	φ 12.5cm H 6cm
		Mishima rice bowl by Yuji Muraki	
15	村木雄児	三島めし碗	φ 12～13cm H 6～6.5cm
		Mishima rice bowl by Yuji Muraki	
16-17	村木雄児	三島めし碗 ディテール	
		Mishima rice bowl by Yuji Muraki (detail)	
18-19	村木雄児	唐津茶碗	φ 14.3cm H 8.1cm
		Karatsu teabowl by Yuji Muraki	
20-21	村田森	黒高麗茶碗	φ 12.5cm H 7cm
		Korai teabowl with black glaze by Shin Murata	
22	郡司庸久	白磁めし碗	φ 13.5cm H 7.5cm
		Rice bowl, White porcelain by Tsunehisa Gunji	
	郡司庸久	灰釉めし碗	φ 13.5cm H 6.8cm
		Rice bowl with ash glaze by Tsunehisa Gunji	
23	阿南維也	青白磁めし碗	φ 10.5cm H 6cm
		Rice bowl, Celadon by Koreya Anan	
	吉田崇昭	染付縞文様めし碗	φ 11.5cm H 6.5cm
		Rice bowl, Blue and white porcelain by Takaaki Yoshida	
	阿南維也	白磁灰釉めし碗	φ 10.5cm H 6cm
		Rice bowl, White porcelain with ash glaze by Koreya Anan	
24-25	吉岡萬理	刷毛目碗	φ 15cm H 7.5cm
		Bowl, Brushmark slip by Banri Yoshioka	
26	小野哲平	カラツ碗金継	φ 14.2cm H 6cm
		Bowl with Karatsu glaze, kintsugi by Teppei Ono	
27	石田誠	南蛮焼締碗	φ 14.1cm H 7cm
		Bowl, Nanban Yakishime by Makoto Ishida	
28-29	尾形アツシ	刷毛目碗	φ 15.8cm H 5.5cm
		Bowl, Brushmark slip by Atsushi Ogata	
		粉引碗	φ 13.6cm H 6cm
		Kohiki bowl by Atsushi Ogata	
		灰釉碗	φ 14.2cm H 6cm
		Bowl with ash glaze by Atsushi Ogata	
		粉引碗	φ 15.7cm H 7cm
		Kohiki bowl by Atsushi Ogata	

皿 Dish

32	村田森	染付8寸八角皿	φ 24cm H 4cm
		Octagon plate, Blue and white porcelain by Shin Murata	
33	村田森	絵付市松楕円皿	φ 21.5cm H 2.4cm
		Oval plate, Blue and white porcelain with lapis lazuli glaze by Shin Murata	
34-35	亀田大介	白磁鎬8寸リム皿	φ 24cm H 3.8cm
		Rim plate, White porcelain line engraving by Daisuke Kameta	
36-37	横山拓也	白化粧5寸皿	φ 15cm H 2.8cm
		Dish, White slipware by Takuya Yokoyama	
38	吉田直嗣	白磁鉄釉皿	φ 22.6cm H 1.8cm
		Dish, White porcelain with iron glaze by Naotsugu Yoshida	
39	八田亨	板皿	W 23.5cm D 23.5cm H 1.8cm
		Board plate by Toru Hatta	
40-41	谷口晃啓	白磁四方皿	φ 12.5～23.5cm D 12.5～23.5cm H 1～1.8cm
		Square plate, White porcelain by Akihiro Taniguchi	
42-43	青木亮	粉引4.5寸皿	φ 13.5cm H 3cm
		Kohiki dish by Ryo Aoki	
44	安永正臣	白磁4寸皿	φ 11.5cm H 3cm
		Small dish, White porcelain by Masaomi Yasunaga	
45	森岡成好	南蛮焼締4寸皿	φ 11.5cm H 3.5cm
		Small dish, Nanban Yakishime by Shigeyoshi Morioka	

鉢 Larger-type bowl

48-49	八田亨	三島6寸鉢	φ 19.5cm H 8.5cm
		Mishima bowl by Toru Hatta	
50-51	光藤佐	黒釉八角鉢	φ 15～18cm H 6.5～7.5cm
		Octagon bowl with black glaze by Tasuku Mitsufuji	
52	横山拓也	白化粧角高台皿	φ 10cm D 10cm H 4cm
		Square foot dish, White slipware by Takuya Yokoyama	
53	亀田大介	白磁台鉢	前：φ 14cm H 5.8cm 奥：φ 15cm H 5cm
		Foot bowl, White porcelain by Daisuke Kameta	
54-55	寒川義雄	堅手小鉢	φ 12cm H 5cm
		Small bowl, Semi porcelain by Yoshio Kangawa	
56	吉田直嗣	白磁三角鉢	φ 14cm H 6cm
		Triangle bowl, White porcelain by Naotsugu Yoshida	
		鉄釉三角鉢	φ 15cm H 5cm
		Triangle bowl with iron glaze by Naotsugu Yoshida	
58-59	巳亦敬一	ガラス高付鉢	φ 20cm H 12cm
		Glass bowl by Keiichi Mimata	
60-61	村木雄児	三島8寸鉢	φ 25cm H 8.5cm
		Mishima bowl by Yuji Muraki	
62-63	木曽志真雄	織部たわめ鉢	φ 28×25cm H 10.5cm
		Oribe bowl by Shimao Kiso	
64-65	小野哲平	櫛目ドラ鉢	φ 29.5cm H 5cm
		Bowl, Combing gong-shaped by Teppei Ono	
66-69	森岡成好	灰釉大鉢	φ 31cm H 8.4cm
		Large bowl with ash glaze by Shigeyoshi Morioka	

茶器 Teapot and tea cup

72-75	村上躍	黒焼締ポット	φ 9.5cm H 9cm
		Pot, Black Yakishime by Yaku Murakami	
76-77	村上躍	赤錆化粧ポット	φ 10.5cm H 10cm
		Pot, Red rust make up by Yaku Murakami	
78	小野哲平	ポット	前：φ 9cm H 9.5cm 奥：φ 8cm H 8.5cm
		Pot, Wood fired kiln by Teppei Ono	
79	矢尾板克則	色化粧ポット	φ 7cm H 11.5cm
		Pot, Color make up by Katsunori Yaoita	
80	尾形アツシ	焼締ポット	φ 9.5cm H 12.5cm
		Pot, Yakishime by Atsushi Ogata	
81	尾形アツシ	刷毛目ポット	φ 11cm H 13cm
		Pot, Brushmark slip by Atsushi Ogata	

82	郡司庸久	白磁ポット	φ10cm H 12cm
		Pot, White porcelain by Tsunehisa Gunji	
83	安永正臣	焼締急須	φ8cm H 7cm
		Teapot, Yakishime by Masaomi Yasunaga	
85	吉岡萬理	色絵ポット	φ10cm H 11cm
		Pot, Overglaze enamels by Banri Yoshioka	
86-87	吉田直嗣	鉄釉コーヒーカップ	φ8.1cm H 6.2cm
		Coffee cup with iron glaze by Naotsugu Yoshida	
		白磁コーヒーカップ	φ8.2cm H 6.5cm
		Coffee cup, White porcelain by Naotsugu Yoshida	
88	吉田直嗣	白磁鉄釉碗	φ7.8cm H 6.6cm
		Bowl, White porcelain with iron glaze by Naotsugu Yoshida	
89	吉田直嗣	白磁灰釉湯呑	φ7cm H 7cm
		Teabowl, White porcelain with ash glaze by Naotsugu Yoshida	
90	青木亮	粉引湯呑	φ6cm H 7cm
		Kohiki teabowl by Ryo Aoki	
		三島湯呑	φ7cm H 6.5cm
		Mishima teabowl by Ryo Aoki	
		粉引湯呑	φ6cm H 7.5cm
		Kohiki teabowl by Ryo Aoki	
91	小野哲平	鉄化粧筒湯呑	φ6.3cm H 7cm
		Teabowl with iron painting by Teppei Ono	
92	亀田大介	白磁面取蕎麦猪口	φ8.5cm H 6.6cm
		Sobachoko, White porcelain line engraving by Daisuke Kameta	
93	青木亮	粉引丸湯呑	φ9cm H 7.5cm
		Kohiki teabowl by Ryo Aoki	

片口　Katakuchi

95	青木亮	刷毛目片口	φ15cm H 7.5cm
		Katakuchi, Brushmark slip by Ryo Aoki	
96	田谷直子	灰釉片口	φ6cm H 4.3cm
		Katakuchi with ash glaze by Naoko Taya	
97	小野哲平	櫛目片口	φ11.5cm D 14cm H 8cm
		Katakuchi, Combing by Teppei Ono	
98	前: 鶴見宗次	手捻り片口	φ7.5cm H 10cm
		Katakuchi, Hand forming by Soji Tsurumi	
	中: 村上躍	銀彩片口	φ9cm D 9cm H 10.5cm
		Katakuchi, Silverdecoration by Yaku Murakami	
	奥: 吉田直嗣	白磁鉄釉片口	φ8cm H 7.8cm
		Katakuchi, White porcelain with iron glaze by Naotsugu Yoshida	
100	横山拓也	白化粧片口	φ12×8.3cm H 6.5cm
		Katakuchi, White slipware by Takuya Yokoyama	
101	横山拓也	黒片口	φ9.5×9cm H 8cm
		Black Katakuchi by Takuya Yokoyama	
103	尾形アツシ	灰釉片口	φ18cm H 8.5cm
		Katakuchi with ash glaze by Atsushi Ogata	
104	小野哲平	呉須水差し	φ10.5cm H 17.5cm
		Pitcher with zaffer glaze by Teppei Ono	

酒器　Sake bottle and sake cup

107	小山乃文彦	粉引徳利	φ8.3cm H 10.3cm
		Kohiki sake bottle by Nobuhiko Oyama	
108	村田森	白磁面取徳利	φ6.5cm H 9cm
		Sake bottle, White porcelain faceted by Shin Murata	
109	村田森	瑠璃釉徳利	φ8cm H 12cm
		Sake bottle with lapis lazuli glaze by Shin Murata	
110	荒賀文成	粉引徳利	φ6cm H 15cm
		Kohiki sake bottle by Fuminari Araga	
111	石田誠	スリップウエア徳利	φ5cm H 12.5cm
		Sake bottle, Slipware by Makoto Ishida	
112	尾形アツシ	粉引ぐい呑み	φ5.5cm H 5.5cm
		Kohiki sake cup by Atsushi Ogata	
	尾形アツシ	粉引ぐい呑み	φ5.5cm H 6cm
		Kohiki sake cup by Atsushi Ogata	
	村田森	鉄絵ぐい呑み	φ5cm H 5cm
		Sake cup with iron painting by Shin Murata	
113	村木雄児	三島ぐい呑み	φ6.5cm H 4cm
		Mishima sake cup by Yuji Muraki	
	青木亮	粉引ぐい呑み	φ9.3cm H 4.3cm
		Kohiki sake cup by Ryo Aoki	
	村田森	刷毛目ぐい呑み	φ8cm H 3cm
		Sake cup, Brushmark slip by Shin Murata	

蓋物　Lidded vessel

115	森岡由利子	白磁面取蓋物	φ12cm H 11.5cm
		Lidded vessel, White porcelain faceted by Yuriko Morioka	
116-117	小野哲平	蓋付壺	φ9.5cm H 13.5cm
		Lidded vessel, Finger drawing by Teppei Ono	
119	吉岡萬理	色絵蓋物	φ10cm H 11cm
		Lidded vessel with overglaze enamel by Banri Yoshioka	

壺・花器　Jar and vase

121	青木亮	鉄釉壺	φ16cm H 20cm
		Jar with iron glaze by Ryo Aoki	
122-123	小野哲平	櫛目筒花器	φ6~24cm H 8~24cm
		Vase, Combing by Teppei Ono	
124-125	村上躍	白砂化粧花器	φ41cm D 20cm H 23cm
		Vase, White sand make up by Yaku Murakami	
126-127	森岡由利子	白磁壺	φ25cm H 27.5cm
		Jar, White porcelain by Yuriko Morioka	
128	尾形アツシ	薪窯灰被り大壺	φ58cm H 62cm
		Big jar with natural ash glaze by Atsushi Ogata	

インタビュー　Ceramist Interview

139	村木雄児	唐津茶碗	φ14.3cm H 8.1cm
		Karatsu teabowl by Yuji Muraki	
143	村上躍	砂化粧花器	W 31cm H 18cm D 9cm
		Vase, Sand make up by Yaku Murakami	
152-153	尾形アツシ	薪窯灰被り刷毛目大壺	φ37cm H 43cm
		Big jar with natural ash glaze Brushmark slip by Atsushi Ogata	
157	尾形アツシ	荒粉引めし碗	φ12cm H 5.5cm
		Kohiki rice bowl by Atsushi Ogata	

祥見知生

ギャラリスト。鎌倉を拠点に、食べる道具の美しさを伝えるテーマ性のある器の展覧会を開く。
著書に『うつわ日和。』『DVDブック うつわびと小野哲平』（ラトルズ）、『日々の器』（河出書房新社）、『器、この、名もなきもの』（里文出版）など。
企画・編集の仕事に『LIVE 器と料理』『TEPPEI ONO』（青幻舎）。
主な展覧会に東京・国立新美術館地階 SFT ギャラリー「TABERU」「うつわ、ロマンティーク展」など多数。
経済産業省事業「The Wonder500」プロデューサーを務める。
鎌倉・うつわ祥見　http://utsuwa-shoken.com/

TOMOO SHOKEN

Gallerist based in Kamakura.
Her exhibitions showcase Utsuwa conveying the beauty of daily use ceramics.
Authored Utsuwa Biyori (Perfect Day for Utsuwa),
Utsuwa-bito Teppei Ono (Ono Teppei: A Person of Utsuwa, DVD Book) (Rutles Inc.), Hibi no Utsuwa (Utsuwa for Daily Life) (Kawade Shobo Shinsha), Utsuwa kono Namonakimono (Utsuwa: An Anonymous Existence) (Ribun Shuppan Co., Ltd). Planned and edited LIVE Utsuwa & Cooking, TEPPEI ONO (Seigensha Art Publishing, Inc.).
Held numerous exhibitions including: TABERU, Utsuwa Romantic at SFT Gallery in the basement of the National Art Center in Tokyo.
Producer of 'The Wonder500' developed by The Ministry of Economy, Trade and Industry.
Kamakura, Utsuwa Shoken　http://utsuwa-shoken.com/

UTSUWA KATACHI — JAPANESE CERAMICS AND FORMS
うつわ かたち

発行日：初版第1刷　2016年7月7日
　　　　第2刷　2024年4月23日

—

著者：
祥見知生

撮影：
西部裕介

ブックデザイン：
橘詰冬樹

翻訳：
冨永真奈美

協力：
杉谷一禎
ハタノワタル

発行者：
久保田啓子

発行所：
株式会社 ADP｜Art Design Publishing
165-0024 東京都中野区松が丘2-14-12
tel: 03-5942-6011 fax: 03-5942-6015
http://www.ad-publish.com
振替：00160-2-355359

—

プリンティングディレクション：
熊倉桂三（株式会社山田写真製版所）

印刷・製本：
株式会社山田写真製版所

—

© TOMOO SHOKEN 2016
Printed in Japan
ISBN978-4-903348-48-3 C0072

用紙
本文：b7バルキー 62.5kg
見返し：NTラシャシルバー 100kg
表紙：ミルトGAスピリットスーパーホワイト 125kg
帯：ミセスBスムースFスーパーホワイト 93.5kg
別冊差込み：HSハミング 74.5kg

—

本書の収録内容の無断転載・複写（コピー）・引用などは、著作権法上での例外を除き、禁じられています。
乱丁本・落丁本はご購入書店名を明記の上、小社までお送りください。
送料小社負担にてお取り替え致します。

UTSUWA KATACHI
JAPANESE CERAMICS AND FORMS

うつわ かたち

祥見知生 編著
TOMOO SHOKEN

SUPPLEMENT — CERAMISTS PROFILES
作家紹介

ADP

A form that evolved from a single trail

When you think of the shape of an utsuwa you envision an imaginary journey along a path. You see an old ceramic ware you sense the ceramist who created it is in front of you. Each ceramist stands on their own trail, gazes at you and talks to you. Time does not diminish its allure, as it still maintains the power to attract the onlooker. It stirs the heart and continues on its journey. A shape is modeled after another shape. Unquestionably not all of the source of inspiration is man-made. The beauty of nature can become the source of inspiration for a form. The beauty of nature is received, digested and a shape is created. The path shows the outcome of a story of human determination. The source of beauty of the utsuwa that is in front of us is not limited by its quantifiable use. Moreover, it was not only the creator that was on the trail. Although there may be a difference in the historical backdrop, we the users exist at all times. We stand on the same track, in the here and now, when we wrap our hands around an utsuawa and use it.

Throughout its history, "names" have long been given to ceramic ware. Names can derive from the glaze, the production areas, the firing method, the background of its birth, techniques and so forth. Many think that knowledge is required to understand utsuwa, but if you focus too much on the meaning of the name you may overlook something. The importance lies in feeling the personality of the utsuwa. If you step away from knowledge and view the piece with the mind's eye, you may notice a new expression that you may have missed before.

By turning the pages of this book, we want you to easily understand the characteristic of each ceramic, whether it be a tea-utensil with accentuated beauty and presence, bowls or small dishes with spur marks that are formed through multiple firing, bowls with "Kintsugi (golden joinery)", pots created using a wood fired kiln with streaks of unwashed ash glaze or bowls with "Ishihaze (stone explosion)" .

Utsuwa that is truly beautiful is occupied by something that words do not do justice to describe. Why do we sense its beauty? I can only presume that there lies something that transcends the sensitivity of an individual.

Tomoo Shoken

* A phenomenon when some stones (mainly feldspar) in the clay burst out on the surface during firing. It is highly valued and considered an aesthetic feature.

A

Akihiro Taniguchi pp.40-41
Born in Kyoto in 1970. Ceramist based in Kyotamba-cho, Kyoto. Produces porcelain ware that exudes a unique warmth. Among them a creation he has been producing for a long time an irregular shaped Hakuji square dish with a stunning white finish.

Atsushi Ogata pp.28-29, 80, 81, 103, 112, 128, 152-153, 157
See p.151

B

Banri Yoshioka pp.24-25, 85, 119
Born in 1963 in Nara prefecture. Ceramist based in Sakurai-shi, Nara prefecture.
His workshop is located near Hase-dera in Nara, adjacent to a clear stream. Specializes in Hakeme brushmark slip, Kohiki and Iroe Overglaze enameling. His utsuwa are cheerful giving the impression of encouragement. Popular among people of all ages.

D

Daisuke Kameta pp.34-35, 53, 92
Born in Fukushima prefecture in 1975. Ceramist based in Beppu, Oita prefecture.
Followed in the footsteps of the family business as the fourth generation of an Obori Soma ware style pottery maker based in Namie, Fukushima prefecture. However, he was affected by the Great Tōhoku Earthquake and was forced to relocate to Kanagwa prefecture and finally Beppu, Oita prefecture, where he resumes his ceramic making. Known for Hakuji pieces that emanates a beautiful soft glaze and expressive utsuwa that is made from natural clay of Beppu.

F

Fuminari Araga pp. 11, 110
Born in Kyoto in 1972. Ceramist based in Yawata-shi, Kyoto. Influences of ceramic making from earlier times can be viewed in his beautiful and streamlined vessels thrown on the wheel. Creates captivating utsuwa that not only has a handsome finish but has a subtle playfulness at the same time.

K

Katsunori Yaoita p.79
Born in Niigata prefecture in 1969. Ceramist based in Nagaoka-shi, Niigata prefecture.
Creates colorful utsuwa and objects that are full of poetic sentiment. The nostalgic halftone shades are reminiscent of well-known landscapes that express his unique view of the world.

Keiichi Mimata p.58-59
Born in Hokkaido in 1958. Glass artist based in Sapporo.
He is a third generation glass artist of the oldest glass workshop in Hokkaido. While preserving the history of the studio, he also creates his original blown glass products. His glass works have a

form that is elegant and tender which radiates warmth and can be used throughout the year.

Koreya Anan p.23
Born in Oita prefecture in 1972. Ceramist based in Oita-shi. Learned ceramic painting in Arita, the home of ceramics then became an independent ceramist. Continues to creates Hakuji and Seihakuji blue-white porcelain in Oita.

M
Makoto Ishida pp.27, 111
Born in Ehime prefecture in 1965. Ceramist based in Matsuyama-shi, Ehime prefecture. Matsuyama produce Komode[*1] (Delft) ceramic ware with a gentle feel and Nanban Yakishime[*2] wares using the wood firing technique with porcelain clay from Tobe. His utsuwa pieces are simple yet capacious, always looking to the original roots of ceramic making. They say that utsuswa pieces reflect the inner-self of the creator. All his pieces have an undeniable charm that exudes warmth.

*1 Ceramic that was originally brought into Japan by Dutch ships during the Edo Period (1603-1868 A.D.) and has been highly-valued and passed on by the masters of tea ceremony and suki-sha (People who enjoy the art of the tea ceremony).

*2 Unglazed yakishime (earthenware fired in the kiln) that was said to have been brought over from the southward foreign countries (in the Edo period). Fired in kilns called the Jyagama (snake kiln).

Masaomi Yasunaga pp.44, 83
Born in Osaka in 1982. Ceramist based in Mie prefecture. Creates utsuwa such as Hakuji, Yakishime and Sometsuke by wood firing using Anagama[*] (cave kiln)

* A kiln made by digging a slope or digging underground. Uses firewood for firing.

N
Naoko Taya p.96
Born in Kanagawa prefecture in 1973. Ceramist based in Sagamihara-shi, Kanagawa prefecture.
Makes everyday vessels with Ruri glaze and Kaiyu ash glazing. She has a style that is understated and casual, and approaches the creation of utsuwa for daily use with the best of care.

Naotsugu Yoshida pp.9, 38, 56, 86-87, 88, 89, 98
Born in Shizuoka prefecture in 1976. Ceramist based in Gotemba, Shizuoka prefecture.
Studied under the Hakuji ceramist, Taizo Kuroda. After becoming an independent ceramist, started creating black utsuwa characterized by Tetsuyu iron glaze with beautiful form and deep shades. Recent Hakuji vessels are showing a deeper depth of texture and coloring. The Hakuji with Tetsuyu iron glaze is his original style which is a fusion of black and white vessels.

Nobuhiko Oyama p.107
Born in 1967 in Kumamoto prefecture. Ceramist based in Tokoname-shi, Aichi prefecture.
After completing the coursework at Tokoname Tounomori Ceramics Lab, he then became an independent ceramist in Tokoname. Utilizing the clay of Tokoname, he is known for his warm Kohiki style that maintains the sheen. He creates utsuwa that is repeatedly held in the palm of the hand in our everyday life.

R
Ryo Aoki pp.42-43, 90, 93, 95, 113, 121
Born in Kanagawa in 1953. First became an artist then a ceramist, based in Fujino-cho, Kanagawa prefecture. Passed away due to a sudden illness in 2005. Creates utsuwa in a rigorous way using Kohiki slip mixture coating, Hakeme brushmark slip, Tetsuyu iron glazing, Hakuji white porcelain techniques. His work has been an inspiration for a wave of young ceramists. In this book we mainly focus on his wood fired ware by using Noborigama (climbing kiln).

S
Shigeyoshi Morioka pp.13, 45, 66-69
Born in Nara prefecture in 1948. Ceramist based in Amano, Wakayama prefecture.
Creates utsuawa such as Nanban Yakishime using Kaiyu and Hakeme techniques with wood firing. He is well known for his broad approach, rugged strength and dynamism that reminds one of the origin of life that modern society has forgotten.

Shimao Kiso pp.62-63
Born in 1954 in Tokyo. Ceramist based in Seto-shi, Aichi prefecture. He creates utsuwa that has a streamlined form that is powerful with a solid presence. His Oribe ceramic pieces have a uniquely beautiful shade of color and uses deep colors that evoke the image of outer space. The shape of the utsuwa conveys beauty when food is served on it.

Shin Murata pp.20-21, 32, 33, 108, 109, 112, 113
Born in Kyoto in 1970. Ceramist based in Kyoto.
Specializes in Sometsuke underglaze painting and Hakuji that are modeled after Koimari and vessels from the Joseon Dynasty of Korea. He is popular for his ceramic painting that he paints with a humorous touch. He also has a studio in "Muan" in South Korea.

Soji Tsurumi p.98
Born in Tokyo in 1967. Ceramist based in Tokoname-shi, Aichi prefecture.
Forms utsuwa by hand, adhering to using natural clay. His work evokes lushness expressed by the richness of the clay material. His utsuwa brings out the best colour of the food that is plated with. His pieces have a rustic feel that matures with age. Initially the vessel has a texture of clay mixed with small pebbles, which

becomes smooth through usage.

T

Takaaki Yoshida p.23

Born in Fukuoka prefecture in 1976. Ceramist based in Chikushino-shi, Fukuoka prefecture.
Started full-fledged ceramic making in Arita then after becoming an independent ceramist has been creating utsuwa with Sometsuke, based on his passion with traditional early Imari patterns. The vessels he has decorated with earnest casual yet refined patterns give a tenderness that makes you feel that you are carrying a plate of kindness to your dining table.

*Sometsuke porcelain that was fired in kilns near Arita in the beginning of the 17th century.

Takuya Yokoyama pp.36-37, 52, 100, 101

Born in Kanagawa prefecture in 1974. Ceramist in Tajimi-shi, Gifu prefecture.
Known for his impressive utsuwa which is created by several layers of white slip coating over black terracotta. His work stands out in their unique form and presence that has an appearance of tranquility and strength showing the inner beauty of the line of clay.

Tasuku Mitsufuji pp.50-51

Born in Hyogo prefecture in 1962. Ceramist based in Asago-shi, Hyogo.
Specializes in Kohiki, Hakeme, Tetsuyu iron glaze and Hakuji.

Teppei Ono pp.26, 64-65, 78, 91, 97, 104, 116-117, 122-123

Born in Ehime in 1958. Ceramist based in Kami-shi, Kochi prefecture.
Following time spent as an apprentice in Tokoname, he relocated to a terraced rice field area on the foothills of Kochi prefecture's beautiful mountains. Creator of bold and reliable vessels for daily use which comfort the users. The vessels are inspired by the simplicity, warmth and rustic richness he nurtured within himself during trips to various Asian countries and India. His work is bold and laid back.

Teppei Terada p.12

Born in Seto, Aichi prefecture in 1979. Ceramist based in Seto-shi.
Born into a long line of potters that have been based in Seto, a city famous for its ceramics since the late Edo period. He makes traditional Seto pottery such as Oribe by using the glaze and kiln that has been handed down for generations. He is also passionate about creating modern vessels for the dining table.

Toru Hatta pp.39, 48-49

Born in 1977 in Ishikawa prefecture. Ceramist based in Sakai-shi, Osaka.
With a passion to pursue the exploration of clay, he creates Kohiki and Mishima paying a great deal of attention to the glaze. With the Mishima plates the color of the clay and the engraved white pattern lines are well balanced, easy for a novice user since the utsuwa complements the coloring of both Japanese and Western cuisine. Carefully engraved lines give the vessel a modern look that adds attractiveness to the dining table with a non lacquered surface that matures through use.

Tsunehisa Gunji pp.22, 82

Born in Tochigi prefecture in 1977. Ceramist based in Mashiko-cho, Tochigi prefecture.
He is a creator of utuswa that utilizes elegant glaze finishes such as Hakuji and ash glazing with beautiful nonchalant shapes and natural lines that are reminiscent of flowing water. His works give the impression as though they are spontaneously made portraying tranquility and elegance.

Y

Yaku Murakami pp.72-75, 76-77, 98, 124-125, 143

See p.142

Yoshio Kangawa pp.10, 54-55

Born in Yamaguchi prefecture in 1963. Ceramist based in Hiroshima-shi.
Creator of utsuwa with various expressions, such as earthenware with defined features using the wood firing technique and semi-porcelain named Hakuji and Katade.

*Utsuwa made by mixing porcelain earth and ceramic earth.

Yuji Muraki pp.14, 15, 16-17, 18-19, 60-61, 113, 139

See p.132

Yuriko Morioka pp.115, 126-127

Born in 1955 in Iwate prefecture. Ceramist based in Amano, Wakayama prefecture.
Began creating Hakuji after Yakishime and earthenware making. Visited the kiln sites of South Korea to learn pottery making. Creates ceramics that are deeply influenced by the vessels of the Joseon Dynasty of Korea. Her Hakuji vase pieces never ceases to charm and fascinate those who look at them with beauty and grace that expresses a feeling of motherhood.

一本の道から、生まれてきたかたち

うつわのかたちを想うとき、眼には見えない一本の道のことを考えます。古いやきものを見つめても目の前にそれらを作った作り手がいることを感じます。彼らはそれぞれ道に立ち、こちらを見つめ、語りかけてきます。時を経てもその力を弱めることなく、見る者を惹き付けます。心を揺さぶり、そして、受け継がれていく。かたちには手本としたかたちが存在しています。もちろん源となったものは人間が作り出したものばかりではありません。かたちの源泉には自然の美しさがあります。自然の美を受け取り、咀嚼し、かたちにする。一本の道を作ってきたのは、そうした人間のひたむきな想いの連鎖なのでしょう。わたしたちの目の前にあるうつわのかたちの基を作ったのは、用途という実測可能なものだけではないのです。さらに、その道には、作り手だけがいたのではありません。時代背景の違いはあるものの、そこに必ず、使い手が存在します。現代において、うつわを手に包み使うとき、わたしたちは、この同じ道に立っているのです。

やきものには、長い歴史のなかで、名づけられた「名前」があります。釉薬、産地、焼成方法、生まれた背景、技法などが名称として広く伝わっています。うつわを知るために知識が必要と思われる方も多いのですが、名を知ることばかりにこだわっていると見落としてしまうことがあります。大切なのはうつわの個性を感じることです。知識を離れ、心の眼で見つめれば、見逃していたかもしれない新たな表情に気がつかれることでしょう。

本書においては、美しさが際立つ気配のある茶器、重ねて焼いたときにできる目跡のある碗や小皿、金継ぎを施した碗、薪窯焼成による自然灰の流れのある壺、石爆のあるめし碗など、繰り返し頁をめくり、各々の個性、見どころを自由に感じいただければと思います。

それにしましても、しみじみ美しいと感じられるうつわには言葉で表しがたいものが宿っています。なぜ、美しいと感じるのか。そこには個人の感性を超えたものが含まれているように思えてなりません。

うつわは、人が生きていくために生まれ、思慮深く美しいかたちをしています。

祥見知生

* 素地に含まれる小石（おもに長石）が、焼け爆ぜて、露出すること。一種の景色と見立てて珍重される。

青木亮　あおき　りょう　pp.42-43, 90, 93, 95, 113, 121
1953年神奈川県生まれ。美術家を経て陶芸家。神奈川県藤野町にて作陶。2005年突然の病にて逝去。
粉引、刷毛目、鉄釉、白磁などの器を厳しく作り、若手陶芸家に影響を与えた。本書には登り窯による薪窯焼成の作品を中心に掲載した。

阿南維也　あなん　これや　p.23
1972年大分県生まれ。大分市にて作陶。
磁器の本場有田にて絵付を学び独立。大分にて白磁や青白磁を作る。

荒賀文成　あらが　ふみなり　pp.11, 110
1972年京都府生まれ。京都府八幡市にて作陶。
美しく無駄のない轆轤から生まれる器には古いやきものへの眼が随所に見られ、端正ばかりではなく、ふとした狭間に遊びこころが同居する魅力あふれる器を作る。

石田誠　いしだ　まこと　pp.27, 111
松山は砥部の磁器土でやわらかな表情のある紅毛手[*1]や、薪窯焼成による南蛮焼締[*2]など、やきもの本来の原点を常に見つめる素朴で包容力のある器を作る。器は作り手本人を映すと言われるが、との表現にも感じられる器のあたたかさが何より魅力のひとつとなっている。

[*1] 江戸時代に阿蘭蛇船によって輸入され茶人や数寄者が珍重し伝えられた手の意。
[*2] 南方から伝わったとされる無釉の焼き締め。蛇窯と呼ばれる窯で焼成される。

尾形アツシ　おがた　あつし　pp.28-29, 80, 81, 103, 112, 128, 152-153, 157
p.155参照

小野哲平　おの　てっぺい　pp.26, 64-65, 78, 91, 97, 104, 116-117, 122-123
1958年愛媛県生まれ。高知県香美市にて作陶。
常滑を経て高知の棚田の美しい山あいにて、使う人を励ます力強く頼りがいのある日々の器を作る。インドやアジアの国々への旅を原点に、素朴さ、あたたかさ、純朴な豊かさを心に蓄え作る器にはごまかしのないおおらかな眼差しが感じられる。

小山乃文彦　おやま　のぶひこ　p.107
1967年熊本県に生まれ。愛知県常滑市にて作陶。
常滑市立陶芸研究所修了、常滑にて独立。常滑の土を生かし、土味を残したあたたかな粉引に定評がある。暮らしのなかで繰り返し手に包まれる器を制作している。

亀田大介　かめた　だいすけ　pp.34-35, 53, 92
1975年福島県生まれ。大分県別府市にて作陶。
福島県浪江の大堀相馬焼の窯元に生まれ4代目として家業を継いで

いたが、震災で被災。神奈川県を経て大分県別府へ移り住み、作陶を再開。ゆったりとした釉調の美しい白磁や、別府の原土を使った表情豊かな器を作る。

寒川義雄　かんがわよしお　pp.10, 54-55
1963年山口県生まれ。広島市にて作陶。
薪窯焼成の引き締まった表情の土もの、白磁や堅手と呼ばれる半磁器の器など、多彩な表現の器を作る。

＊磁器土と陶器土の土を合わせて制作される器。

木曽志真雄　きそしまお　pp.62-63
1954年東京都生まれ。愛知県瀬戸市にて作陶。
無駄のないフォルム、力強さがあり存在感にあふれる器を作る。濃淡の美しい独特の織部は、宇宙を連想させる深い色を表現。料理を受け止めるかたちの美しさがある。

郡司庸久　ぐんじつねひさ　pp.22, 82
1977年栃木県生まれ。栃木県益子町にて作陶。
白磁、灰釉など、たおやかな釉調や、何気ないかたちの美しさ、水の流れを思わせる自然なラインを生かし、作意がなく、ふと生まれてきたような、静かで優美な器を作る。

谷口晃啓　たにぐちあきひろ　pp.40-41
1970年京都府生まれ。京都府京丹波町にて作陶。
あたたかみのある磁器の器を中心を制作。なかでも白磁四方皿はゆらぎのあるかたちと美しい白が際立ち、永く制作されている作品。

田谷直子　たやなおこ　p.96
1973年神奈川県生まれ。神奈川県相模原市にて作陶。
瑠璃釉、灰釉など、暮らしに寄り添う器を作る。作風はさり気なく控えめで、暮らしのなかで使われる器に丁寧な仕事で向き合っている。

鶴見宗次　つるみそうじ　p.98
1957年東京都生まれ。愛知県常滑市にて作陶。
原土にこだわり手びねりで器を作る。豊かな土の表情が滋味深い。食材の色を美しく映す器は使ってさらに育つ素朴なよさがある。土の肌合いは最初は小石まじりの手ざわりだが、使いこむことで風合いが変わってくる。

寺田鉄平　てらだてっぺい　p.12
1975年愛知県瀬戸市生まれ。瀬戸市にて作陶。
日本を代表する窯業地・瀬戸で江戸時代後期より代々続く窯元に生まれる。織部をはじめとし、釉薬や窯を先祖代々受け継ぎ瀬戸伝統のやきものを作るなかで、現代の「食卓で使われる」器に熱心に取り組む。

八田亨　はったとおる　pp.39, 48-49
1977年石川県生まれ。大阪府堺市にて作陶。
土の可能性を追求し、土味にこだわり粉引、三島を作る。土の色と、線彫りした白い文様のバランスが美しい三島の皿は、和洋を問わず食材の色を引き立てるので器の初心者にも使いやすい。丁寧に線彫りした表情はモダンで、食卓に映える。使うほどに土肌がしっとりと育ってくる。

光藤佐　みつふじたすく　pp.50-51
1962年兵庫県生まれ。兵庫県朝来市にて作陶。
粉引、刷毛目、鉄釉、白磁などを制作。

巳亦敬一　みまたけいいち　pp.58-59
1958年北海道生まれ。札幌市にてガラスの器を制作。
北海道で最も古い歴史を持つガラス工房の三代目。工房の歴史を守りながら、吹きガラスによる作品を製作している。優美で細やかなかたちは、季節を問わず一年中使うことのできる、ぬくもりのあるガラス作品である。

村上躍　むらかみやく　pp.72-75, 76-77, 98, 124-125, 143
p.147 参照

村木雄児　むらきゆうじ　pp.14, 15, 16-17, 18-19, 60-61, 113, 139
p.137 参照

村田森　むらたしん　pp.20-21, 32, 33, 108, 109, 112, 113
1970年京都府生まれ。京都にて作陶。
古伊万里、李朝の器を手本に染付けと白磁。陰刻や陽刻など、手間のかかる仕事に見るべきものがある。朗らかな筆で描くユーモアのある絵付けが人気となる。現在は韓国にも工房を持つ。

森岡成好　もりおかしげよし　pp.13, 45, 66-69
1948年奈良県生まれ。和歌山県天野にて作陶。種子島を訪れたことがきっかけとし南蛮焼締を中心に灰釉、刷毛目などの器を薪窯焼成で作る。現代人が忘れかけた生きる原点を感じさせ出るスケールの大きさ、潔さ、力強さが最大の魅力である。

森岡由利子　もりおかゆりこ　pp.115, 116-117
1955年岩手県生まれ。和歌山県天野にて作陶。
焼締、土器を経て白磁制作を始める。韓国の窯場を訪れ陶器作りの実際を学び、李朝の器に深い想いを馳せ作陶を続けている。母性を感じさせる美しくたおやかな白磁の壺は見つめる者を魅了してやまない。

矢尾板克則　やおいたかつのり　p.79
1969年新潟県生まれ。新潟県長岡市にて作陶。

詩情あふれる作風で色化粧の器やオブジェを作る。既知の風景を感じさせる中間調の懐かしい色合いは独特の世界観を感じさせる。

安永正臣　やすなが まさおみ　pp.44, 83
1982年大阪府生まれ。三重県伊賀市にて作陶。
穴窯による薪窯焼成で白磁、焼締、染付などの器を作る。

★ 斜面を掘ったり、地中を掘り抜くなどして作られた窯。薪で焼成される。

横山拓也　よこやま たくや　pp.36-37, 52, 100, 101
1974年神奈川県生まれ。岐阜県多治見市にて作陶。
黒土に何度も白化粧を施した印象的な器をつくり注目される。それらは独特のかたちと存在感が際立つ。静けさと力強さの両方を内包した佇まいから土の線の美しさが訴えてくる。

吉岡萬理　よしおか ばんり　pp.24-25, 85, 119
1963年奈良県生まれ。奈良県桜井市にて作陶。
奈良は長谷寺のほど近く、清流の流れる場所に工房を持つ。刷毛目、粉引、色絵。おおらかで人を励ます朗らかな器には世代を超えた人気がある。

吉田崇昭　よしだ たかあき　p.23
1976年福岡県生まれ。　福岡県筑紫野市にて作陶。
有田で本格的にやきものを始め、独立後は伝統的な初期伊万里の文様などに熱心に取り組み、染付の器を作っている。何気ない文様を熱心に描くそれらの器は日常に寄り添い、食卓に優しさを運ぶような優しさがある。

★ 17世紀前期、有田周辺の窯で焼成された染付磁器。

吉田直嗣　よしだ なおつぐ　pp.9, 38, 56, 86-87, 88, 89, 98
1976年静岡県生まれ。静岡県御殿場にて作陶。
白磁作家・黒田泰蔵氏に師事。独立後は鉄釉の黒の器を作り、美しいかたち、深い色合いで独自の世界を作り出した。近年取り組んだ白磁の器は焼成方法、釉薬などの違いにより質感や色に表現の幅が生まれている。鉄釉をかけた白磁は黒と白の作風をミックスさせたオリジナルの作風。

SUPPLEMENT — CERAMISTS PROFILES
UTSUWA KATACHI JAPANESE CERAMICS AND FORMS

DATE OF PUBLICATION: FIRST PRINTING JULY 7, 2016
SECOND PRINTING APRIL 23, 2024

—

AUTHOR:
TOMOO SHOKEN

BOOK DESIGN:
FUYUKI HASHIZUME

TRANSLATION:
MANAMI TOMINAGA

PUBLISHER:
KEIKO KUBOTA

PUBLISHING HOUSE:
ADP COMPANY | ART DESIGN PUBLISHING
2-14-12 MATSUGAOKA, NAKANO-KU, TOKYO 165-0024 JAPAN
TEL: 81-3-5942-6011 FAX: 81-3-5942-6015
http://www.ad-publish.com

—

PRINTING DIRECTION:
KATSUMI KUMAKURA (YAMADA PHOTO PROCESS, INC.)

PRINTING & BINDING:
YAMADA PHOTO PROCESS, INC.

うつわ かたち 別冊：作家紹介

発行日：初版第1刷　2016年7月7日
　　　　第2刷　2024年4月23日

—

著者：
祥見知生

ブックデザイン：
橋詰冬樹

翻訳：
冨永真奈美

発行者：
久保田啓子

発行所：
株式会社 ADP | Art Design Publishing
165-0024 東京都中野区松が丘2-14-12
tel. 03-5942-6011 fax: 03-5942-6015
http://www.ad-publish.com

—

プリンティングディレクション：
熊倉桂三（株式会社山田写真製版所）

印刷・製本：
株式会社山田写真製版所

© TOMOO SHOKEN 2016
PRINTED IN JAPAN
ISBN978-4-903348-48-3 C0072